FEB 2 2013

TALKING PICTURES

ALSO BY RANSOM RIGGS

MISS PEREGRINE'S HOME FOR PECULIAR CHILDREN

itbooks

AN IMPRINT OF HARPERCOLLINS*PUBLISHERS*

TALKING PICTURES

IMAGES AND MESSAGES RESCUED FROM THE PAST | RANSOM RIGGS

HarperCollins books may be purchased for educational,
business, or sales promotional use. For information
please write: Special Markets Department, HarperCollins
Publishers, 10 East 53rd Street, New York, NY 10022.

FIRST EDITION

Designed by Lorie Pagnozzi

Library of Congress Cataloging-in-Publication Data is
available upon request.
ISBN 978-0-06-209949-5
12 13 14 15 16 OV/SCP 10 9 8 7 6 5 4 3 2 1

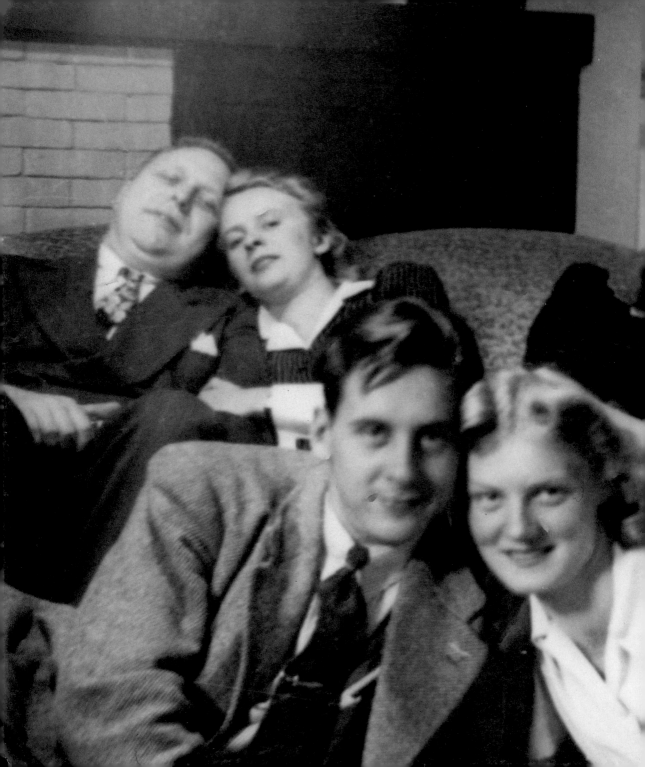

CONTENTS →→→

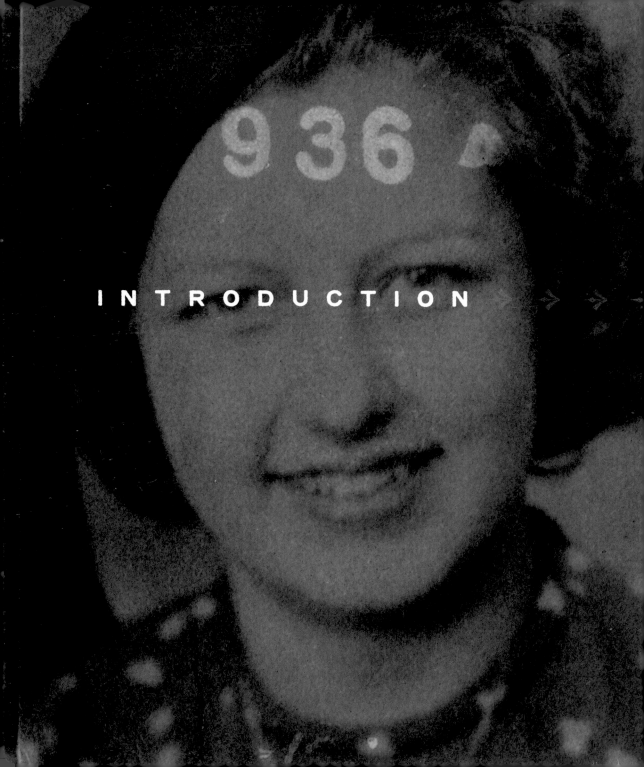

INTRODUCTION

I HAVE AN UNUSUAL HOBBY: I COLLECT PICTURES OF PEOPLE I DON'T KNOW.

It started when I was a kid growing up in South Florida—the land of junk stores, garage sales, and flea markets—as a kind of coping mechanism. Despite my best efforts to avoid them, I was often dragged along on Sunday afternoon antiquing expeditions, down dim and dusty aisles crowded with needlepoint portraits and moth-eaten sport coats—a hell-scape for any boy of thirteen—where occasionally, while my grandmother hunted for bargains, I would find caches of old snapshots. They were photos of strangers, of weddings and funerals, family vacations, backyard forts, and first days of school, all torn from once-treasured albums and dumped into plastic bins for strangers to paw through: communal graves of a sort, the anonymous dead shuffled into ersatz families of the unwanted. I spent hours sifting through the bins, the faces blackening my fingertips.

What fascinated me about them—even more than the images themselves, at first—was that they were available for sale at all. I wondered how people could give away pictures of their families, even those of distant relatives they might not know or remember. Why would they give these photographs up—why, for that matter, would complete strangers want them?

The first question was almost too grim to ponder. As for why people would want them, I began to understand it the first time a snapshot really caught my eye. It was a portrait of a pretty girl who bore an uncanny resemblance to someone I'd suffered a hopeless crush on at summer camp. I found her smiling up at me from a shoebox, encased in a little cardboard frame, and knew in an instant that she was destined to become my fantasy girlfriend. I ponied up a quarter, took her home, and propped her on my nightstand, where for the better part of a year she occupied a hallowed spot between cardboard likenesses of Nolan Ryan and Ken Griffey, Jr. It was fun to wonder who she was and what her life might've been like.

When I finally outgrew baseball cards and fantasy girlfriends, I decided to retire them from my nightstand into a proper album. But the girl's picture wouldn't fit because of its cardboard frame. Ever so carefully, as if performing important surgery, I pried it out. Turning it over in my hands, I saw the back for the first time.

For a long while I just sat on the edge of my bed, staring at it. I'd spent months imagining a life for this person, and in an instant it was all erased. She was no longer anonymous. Now she had a name—Dorothy—and a city, and a fate. I'd been fantasizing about a dead girl.

Of course, many of the snapshots I'd handled were of dead people; they were old pictures, after all. But the discovery that Dorothy, who looked so young and alive in her photo, had likely died just months after it was taken, hit me pretty hard. I found myself grieving, in a small, quiet way, for a person I had never known, who had been dead now much longer than she'd been alive, and whose

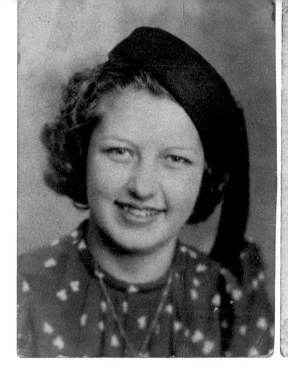
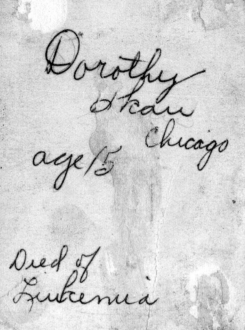

own family had probably not thought of her in decades. Smiling and doomed, Dorothy haunted me for some time.

Fifteen years passed before I bought another snapshot. Once I crossed that threshold, though, my old hobby blossomed into an obsession. I became a collector, albeit an odd one; my primary interest was in snapshots that had writing on them. This had advantages and disadvantages. Among other things, by looking at only the backs of the photos, I could sort through a bin of a thousand snapshots in just a few minutes. But interesting captions were pretty rare, so more often than not I'd walk away empty-handed. I never worried about other collectors buying the photos I wanted before I could get to them, though, because my favorites were almost always diamonds in the rough. Dorothy taught me that a great snapshot doesn't have to meet the aesthetic standards by which we judge other types of

photography. A photo might seem absolutely ordinary, but for a few words scribbled on the opposite side. Like this one, they're hidden gems:

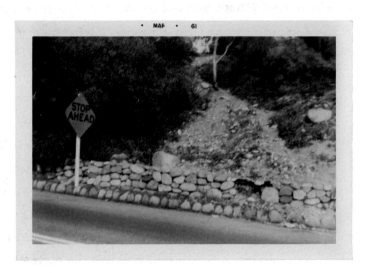

Judging only by the front side, it's as banal as snapshots get: a wall, a sign, and some bushes. It's flat; it's boring; it's not even in focus!

Flip it over, though, and the picture is transformed:

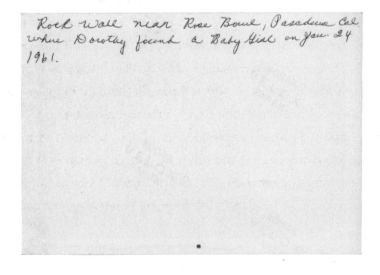

Now it's much more than just a wall: it's a scene imbued with pathos and drama, the strength of which has little to do with composition or tone or even, really, the subject of the photo itself. What's pictured on the front is a reminder, a sort of keepsake, inscribed so that Dorothy might never forget where she was on the day she found a baby girl by the side of the road. (That her name is also Dorothy is an uncanny coincidence not lost on me.)

Maybe the girl had been abandoned by her mother. Maybe she'd been there all night, a cold one even for Southern California in January, and if Dorothy hadn't found her when she did, the baby wouldn't have survived. Maybe this affected Dorothy so profoundly that she returned to the spot again and again, compelled by something she couldn't quite name, and on one of those trips brought along a camera. Maybe the picture is blurred because she couldn't stop her hands from shaking as she took it. We'll never know, but thanks to the inscription on the back we can at least wonder. It lent the mutest of snapshots a voice.

The best inscriptions make a snapshot feel current, no matter when it was taken. They have an immediacy that transcends era, and counteracts the distancing effect old snapshots can have. As a kid, I found it hard to believe that photos of my grandmother as a young girl, posing stiffly in a sepia-toned world, could actually have been taken during her lifetime. They seemed like artifacts from some ancient civilization. That's because old photos have a way of looking older than they really are, focusing our attention on all that's outmoded and obsolete: technology, styles of dress, and other such cultural ephemera.

Great inscriptions have the opposite effect. They allow us to recognize something of ourselves in the blurred and yellowing faces of our forebears. By echoing something timeless, they remind us of all that *hasn't* changed: the ache of long-distance love (page 58); the anxiety felt by parents sending their children off to

war (pages 158–59); that everyone, at one time or another, has felt self-conscious about the way they look in pictures (pages 264–65). If any of these snapshots can speak, I think what they say is: things aren't so different.

Sometimes a word is worth a thousand pictures.

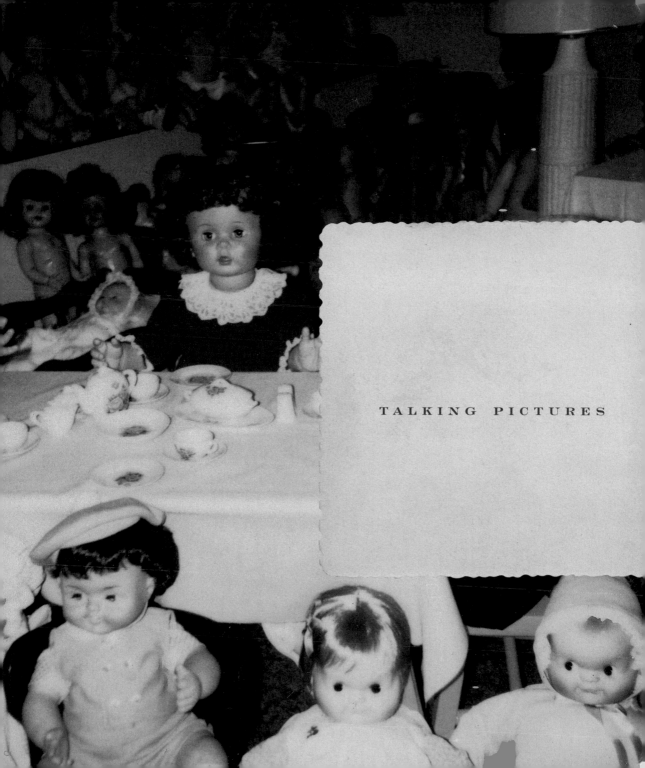

TALKING PICTURES

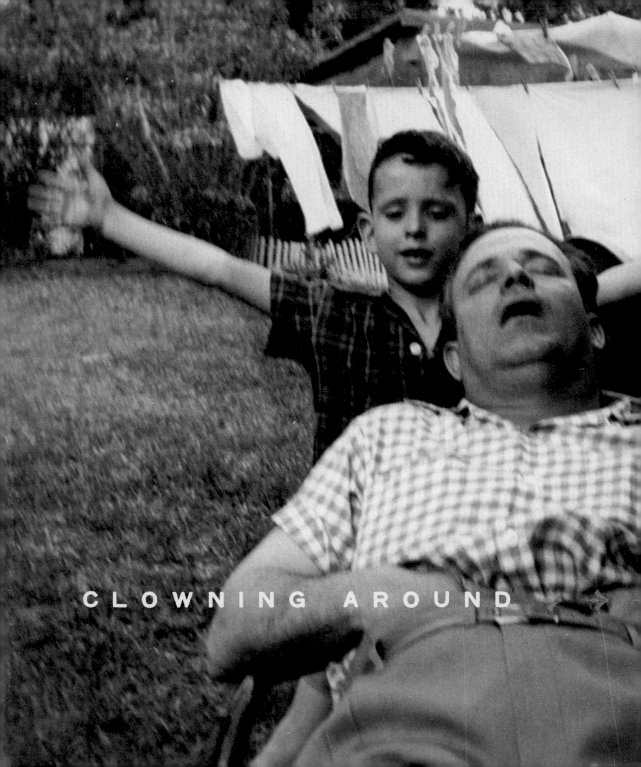

CLOWNING AROUND

Me + My Gal (?)

2

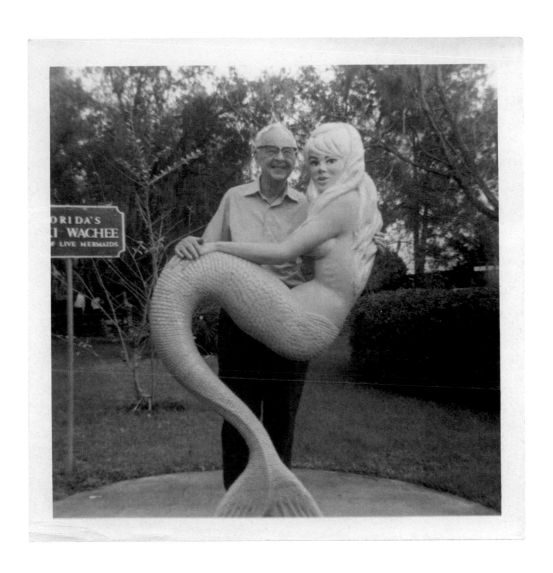

3

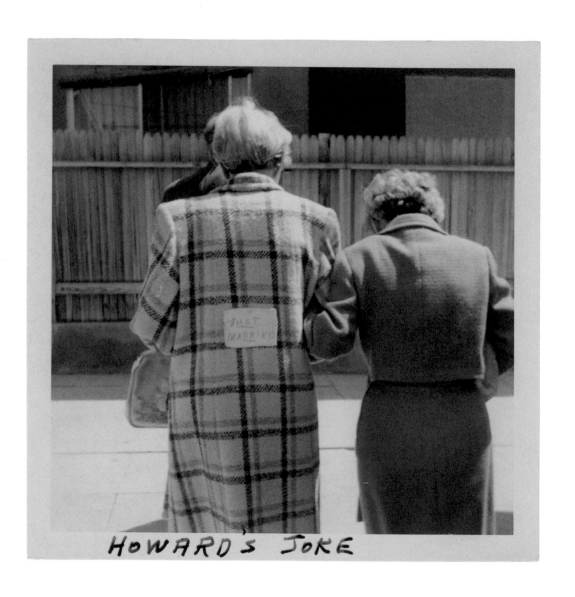

HOWARD'S JOKE

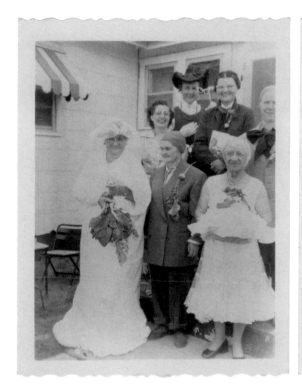

Preacher Pauline Drake
Bride Gladys Garland
Groom. Opal Wagoner
Ring girl Emma Shepherd
Singer arpajean wentzel
mothering law Rosemary
 Thompson
Father annis Dunkelberger

5

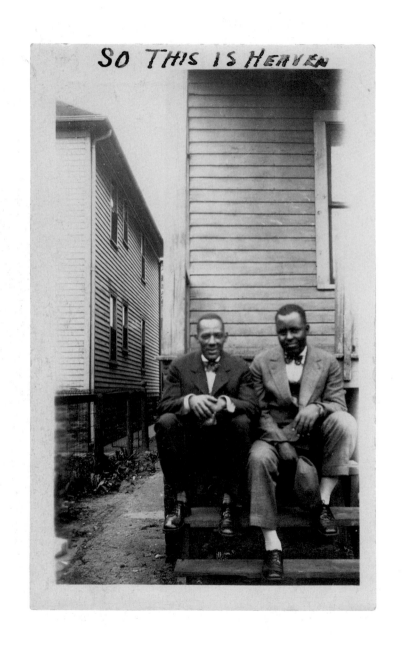

6

Drunk But Happy.

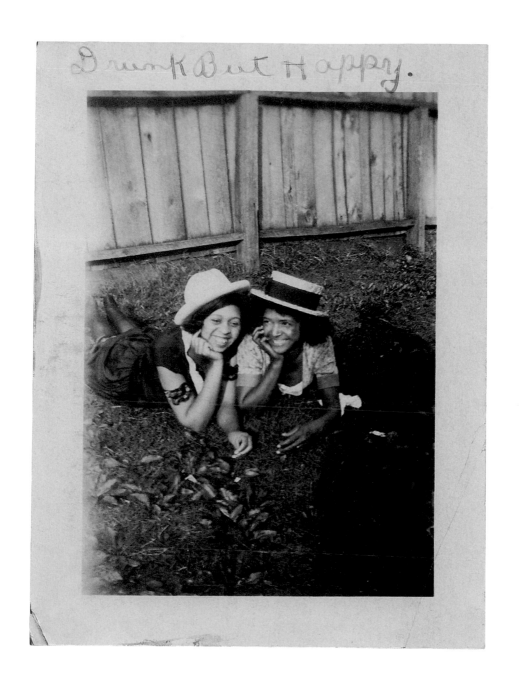

IF THE SIGN SAID
SEGRAM SEVEN INSTEAD
OF "7 UP" I'D BE INSIDE.

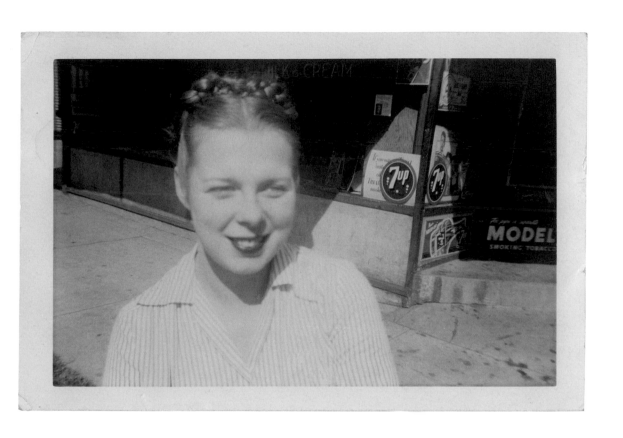

9

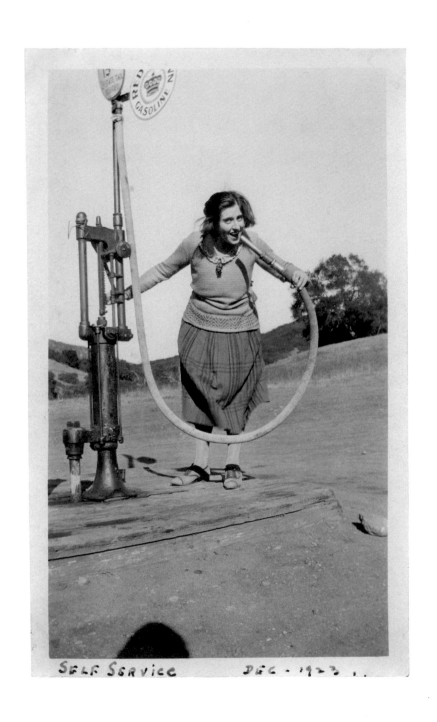

SELF SERVICE DEC - 1923

10

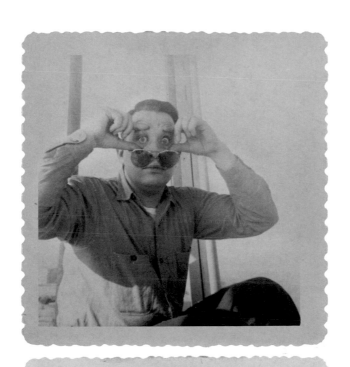

"Red Eye" Gates.

the morning after.

napping with
the glasses

12

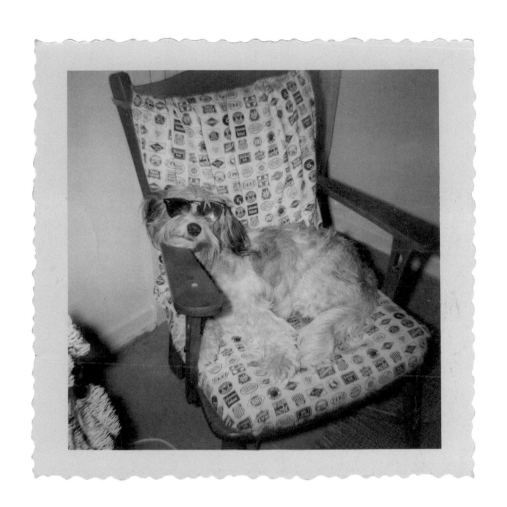

13

Mansville N.Y.

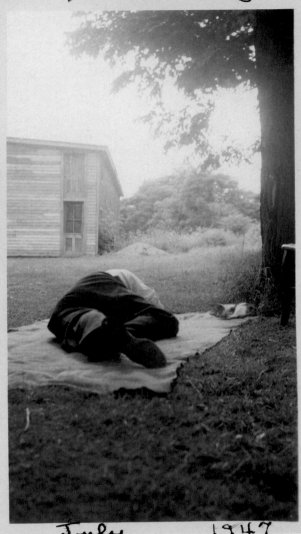

July 1947
Francis taken a nap

14

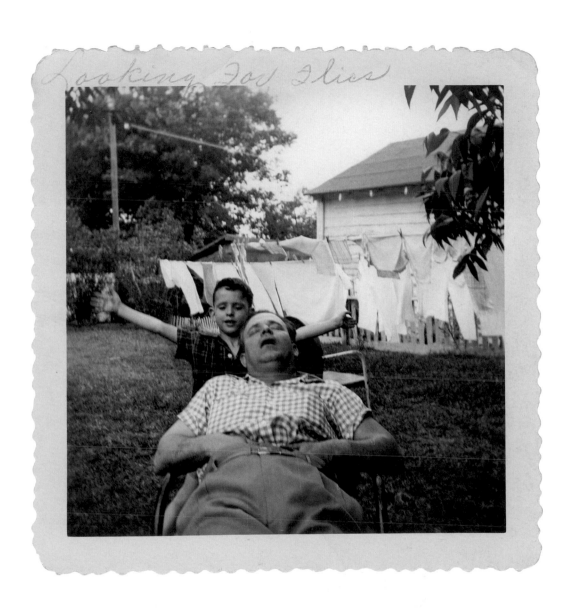

Looking For Flies

15

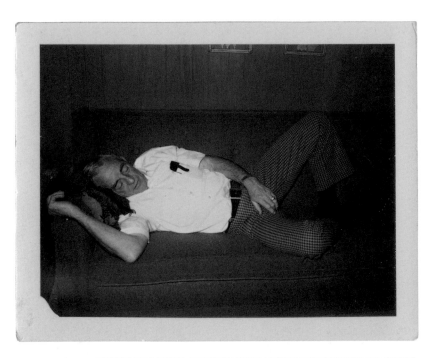

I've Got The Whole World In My Hand

16

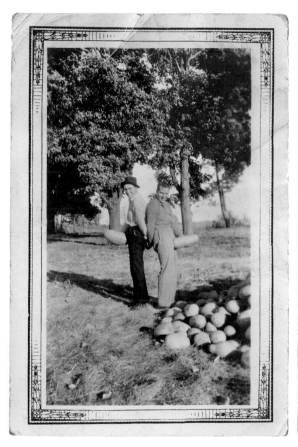

a bad scene
between Bell &
orville
1940

17

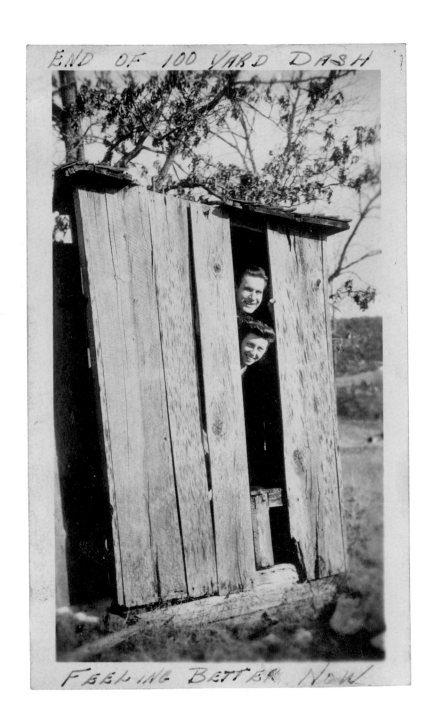

END OF 100 YARD DASH

FEELING BETTER NOW

18

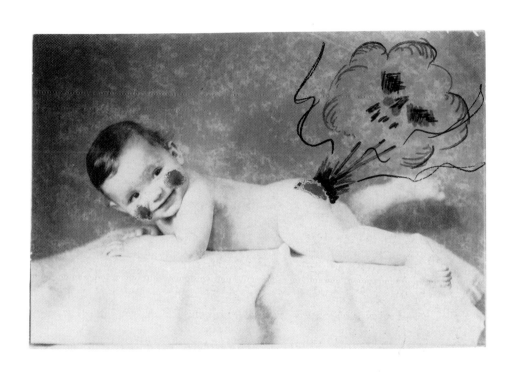

19

PRICIE

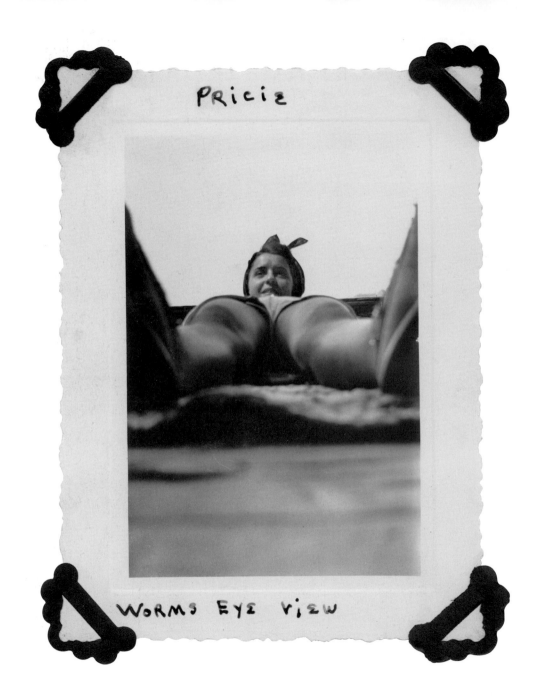

WORMS EYE VIEW

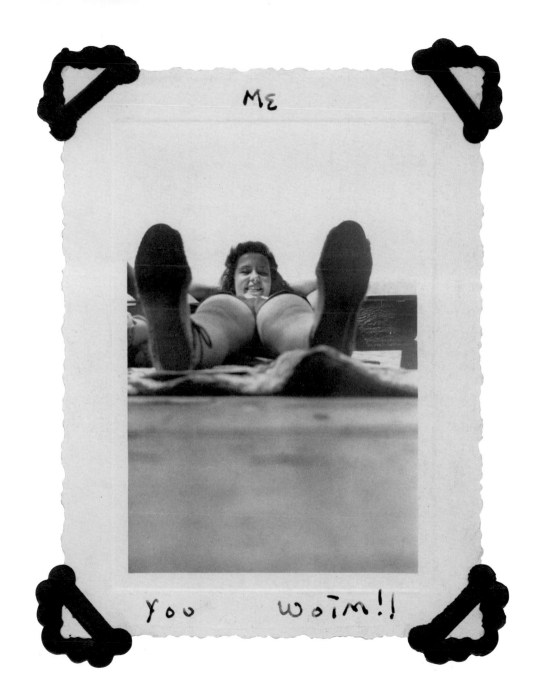

ME

YOO WOIM!!

CAUGHT IN THE ACT
WITH A CIGGERETTE IN
MY FACE.
LOOK NATURAL.

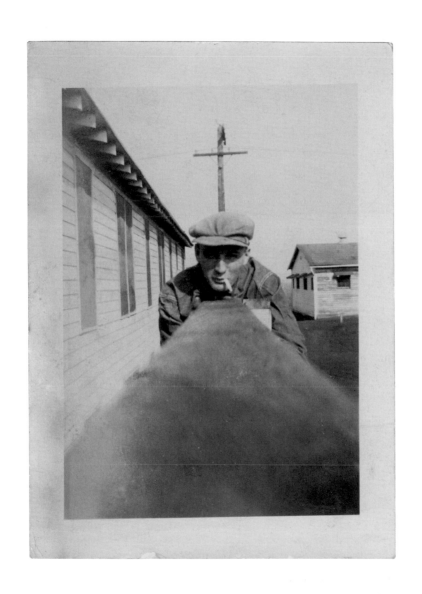

She tries but she
can't.

24

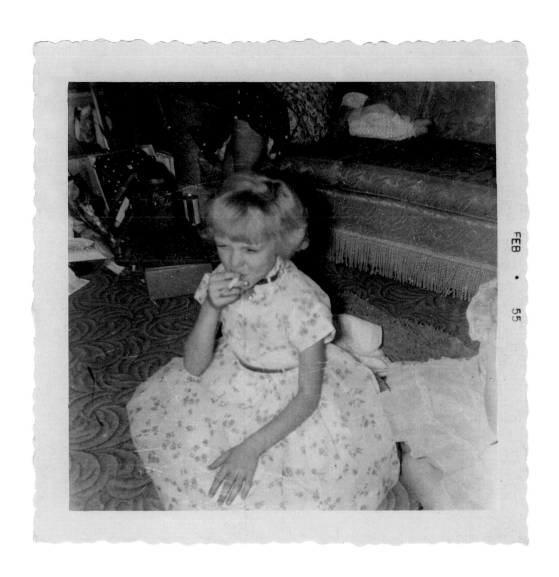

FEB • 55

25

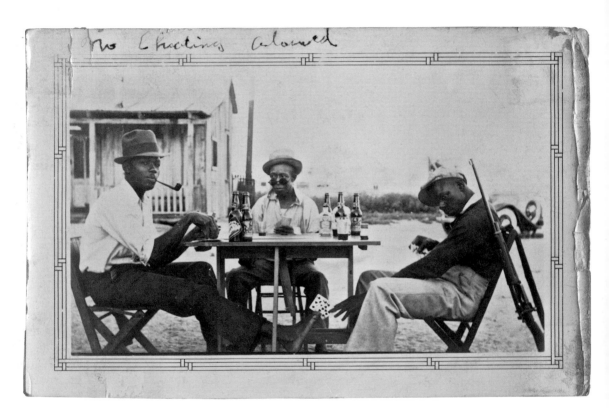

NO CHEATING ALLOWED

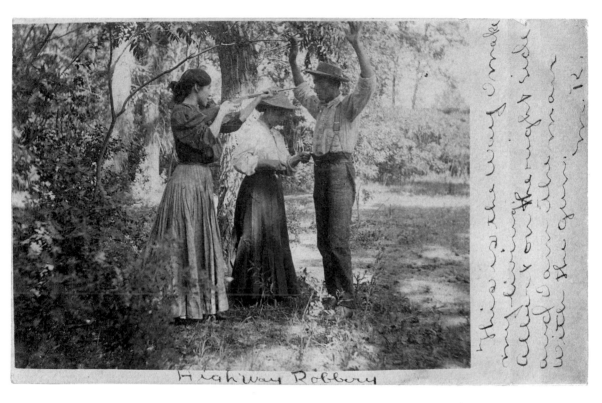

Highway Robbery

This is the way I make my living and Albert on the right side and I am the man with the gun. Wm. T.

HIGHWAY ROBBERY
THIS IS THE WAY I MAKE MY
LIVING. ALBERT ON THE
RIGHT SIDE AND I AM THE
MAN WITH THE GUN.

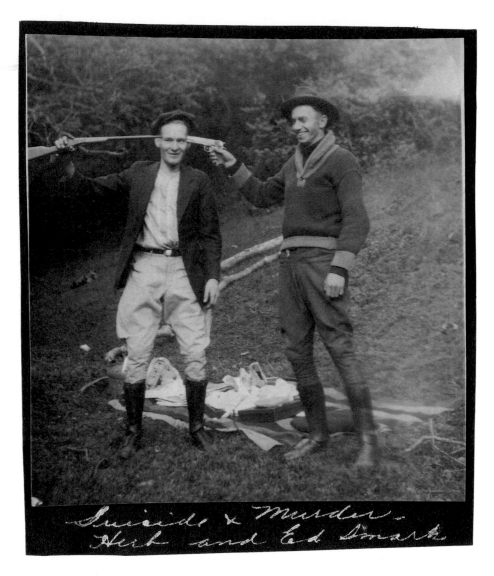

SUICIDE + MURDER

HERB AND ED SMART

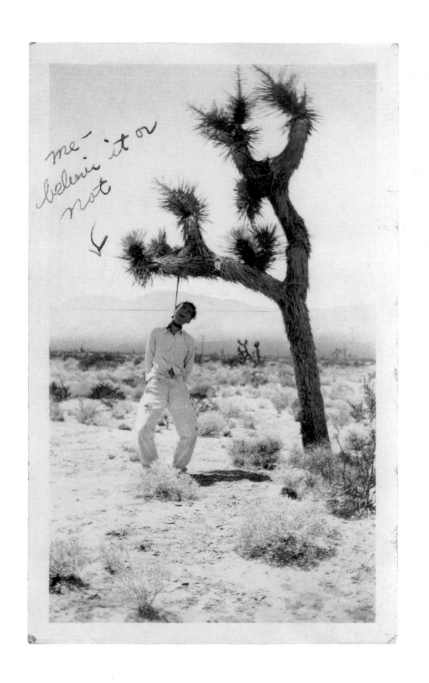

me—
believe it or
not
←

29

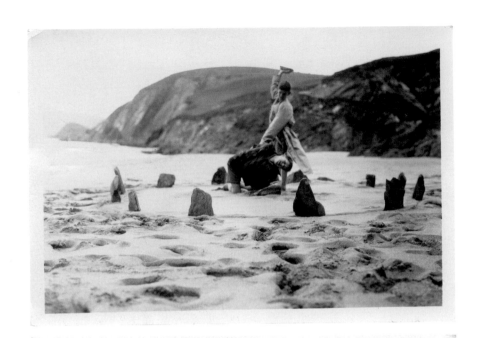

Bob and Amos enact a Druid sacrifice

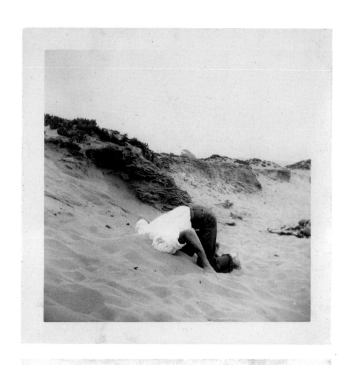

The ostrich himself!
(Phil)

Sept '48 Cal

4090

ANUAL BATH.
MYSELF WITH MY FRIENDS
WIFE. TO WHOM I RECENTLY
ACTED AS BEST MAN.

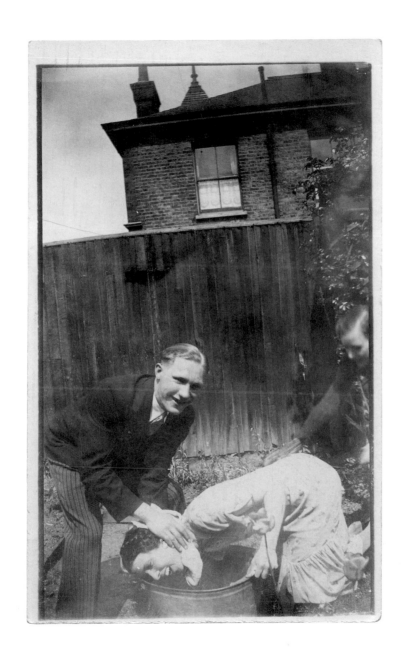

33

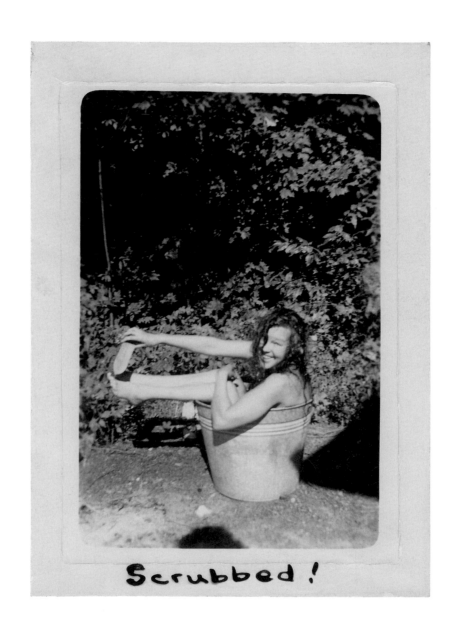

Scrubbed!

34

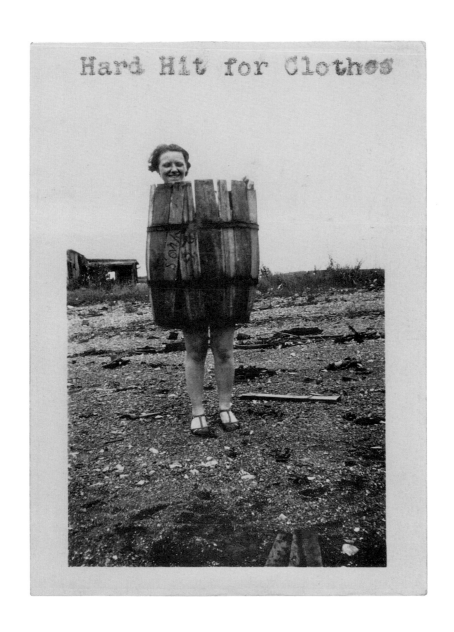

35

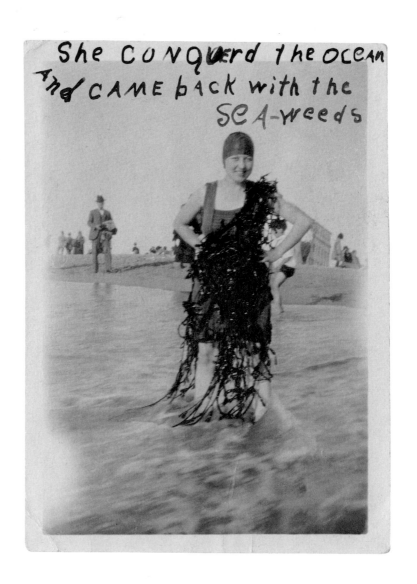

She CONQuerd the OCEAN And CAME back with the SEA-weeds

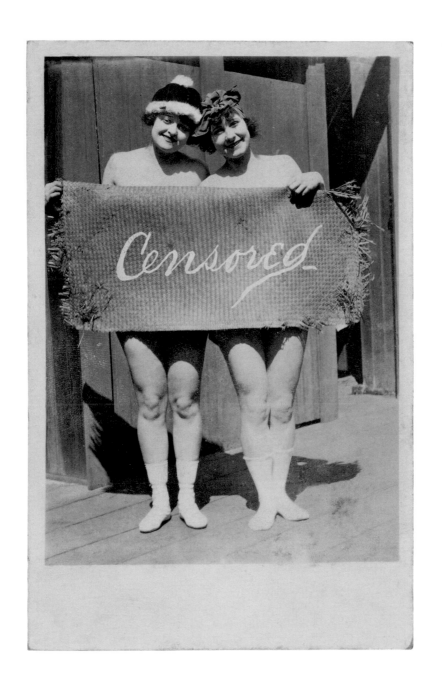

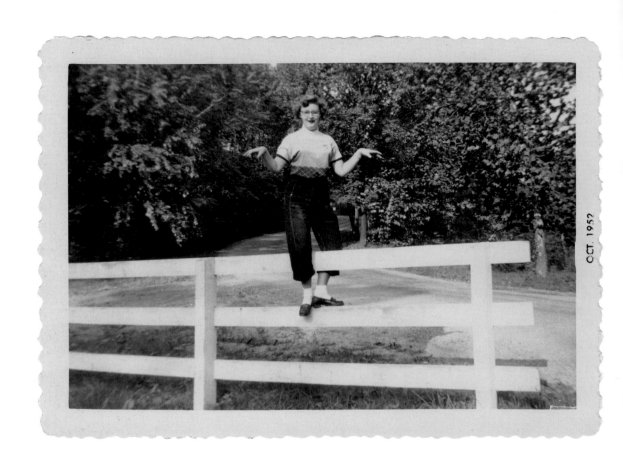

OCT. 1952

Just clowning around.

LOVE AND MARRIAG

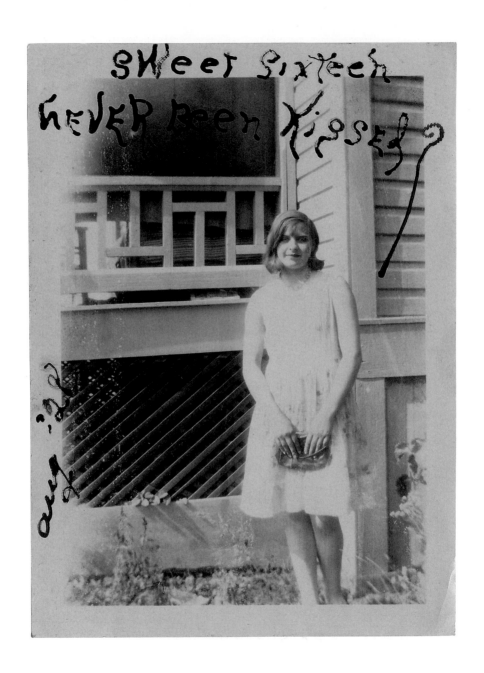

42

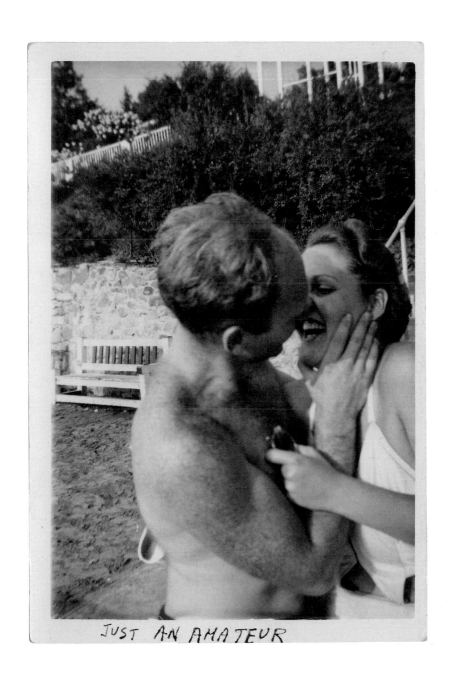

JUST AN AMATEUR

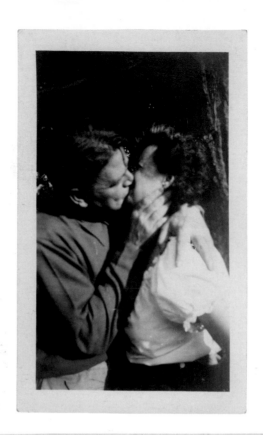

This one doesn't need an explanation

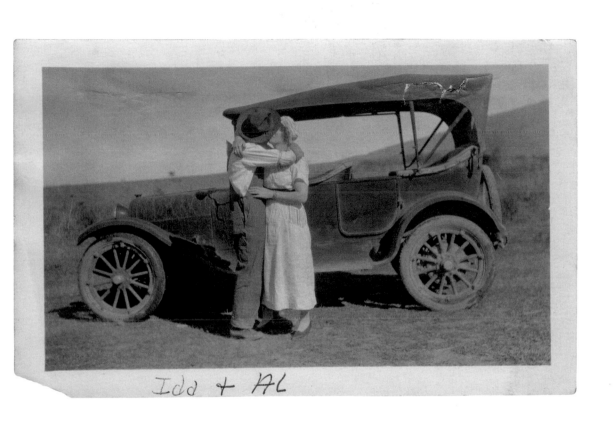

Ida + Al

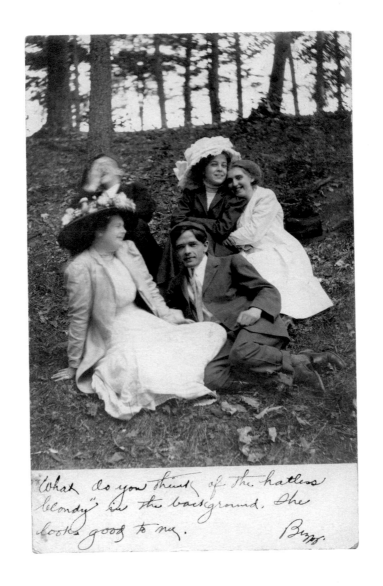

"What do you think of the hatless
blondy" in the background. She
looks good to me.

Buzz.

46

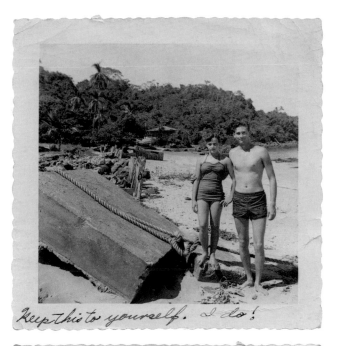

Keep this to yourself. I do!

Actually she is too
small. I Will
throw her back when
I get through with
her.

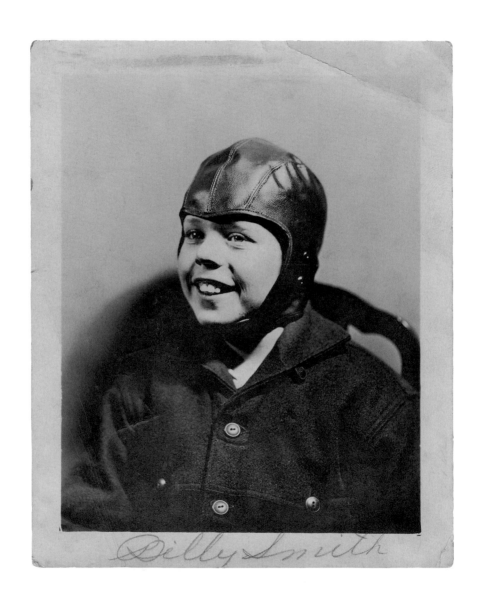

Billy Smith

48

From Billy
Smith

To Thelma

My sweet-
Heart

49

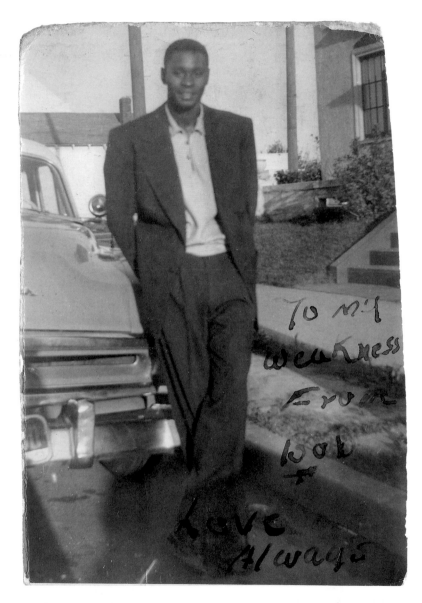

TO MY WEAKNESS
FROM BOB
LOVE ALWAYS

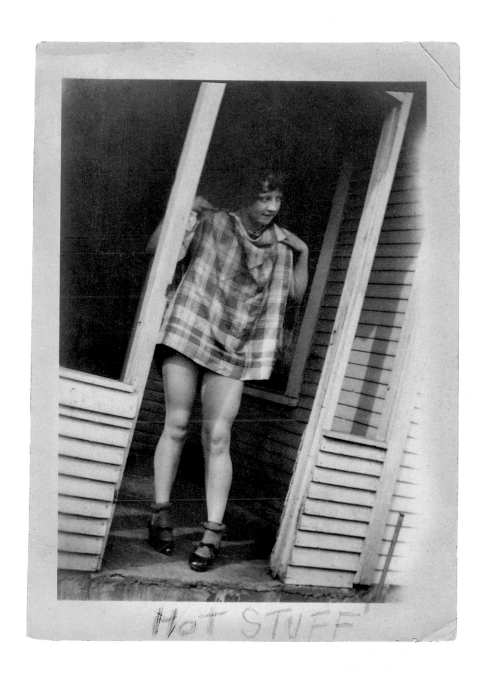

HOT STUFF

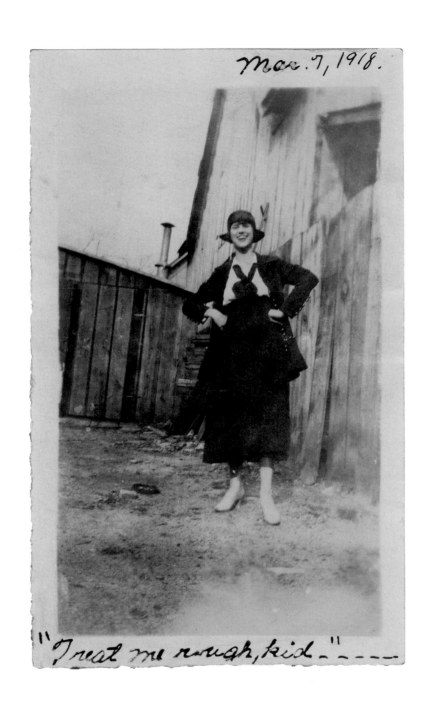

Mar. 7, 1918.

"Treat me rough, kid."——

52

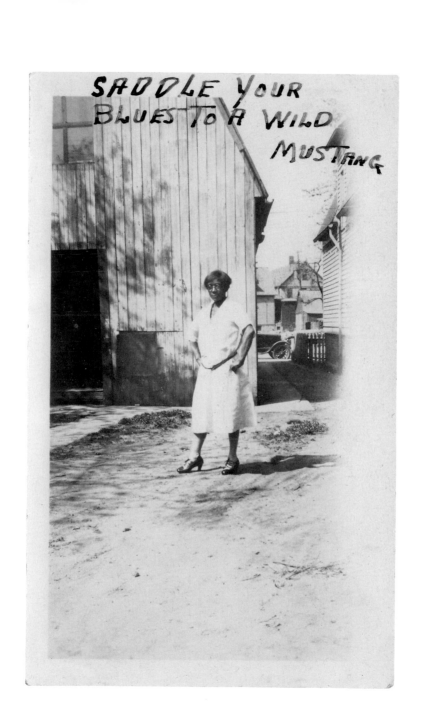

SADDLE YOUR
BLUES TO A WILD
MUSTANG

53

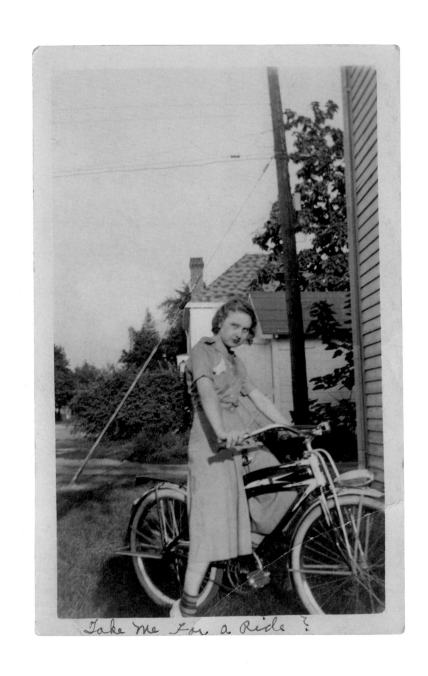

Take Me For a Ride?

54

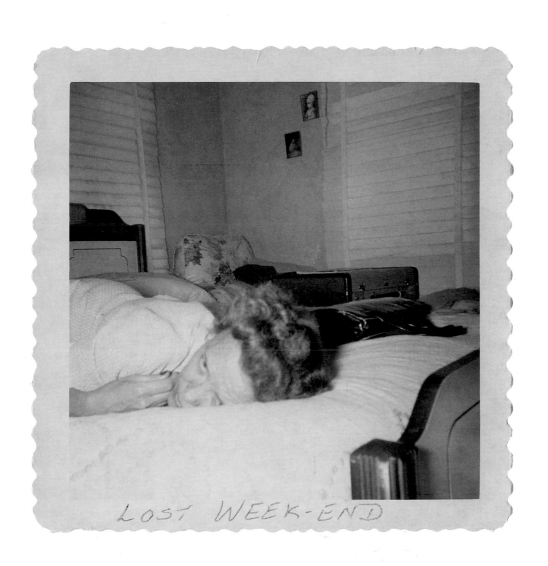

LOST WEEK-END

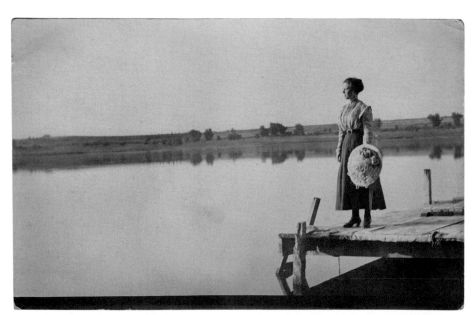

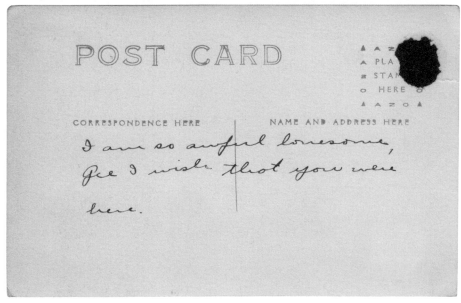

I AM SO AWFUL LONESOME, GEE I WISH THAT YOU WERE HERE.

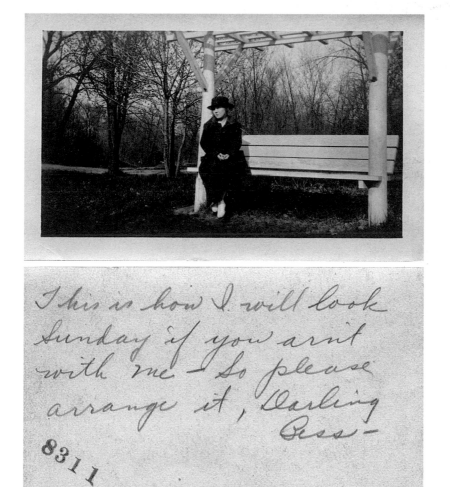

THIS IS HOW I WILL LOOK SUNDAY IF YOU ARN'T WITH
ME—SO PLEASE ARRANGE IT, DARLING BESS

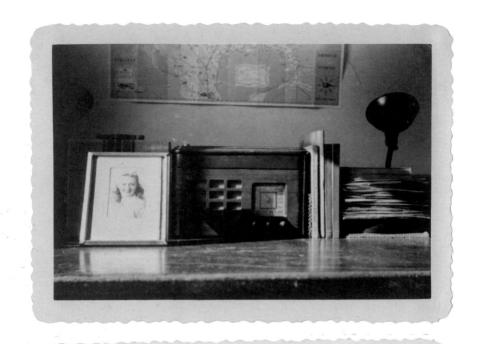

MY DESK —
WHERE I DO
ALL 330 MY
HOMEWORK &
WRITE LETTERS
TO YOU

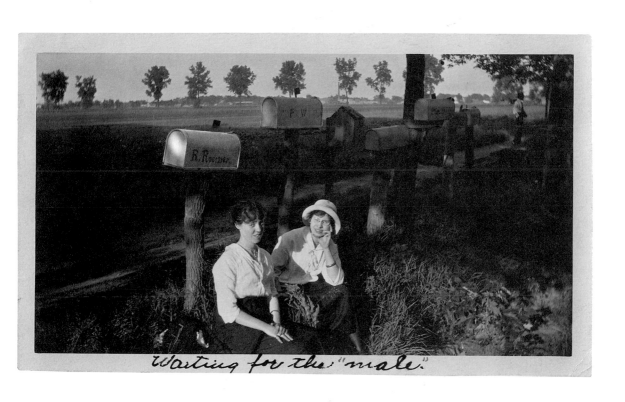

Waiting for the "male."

59

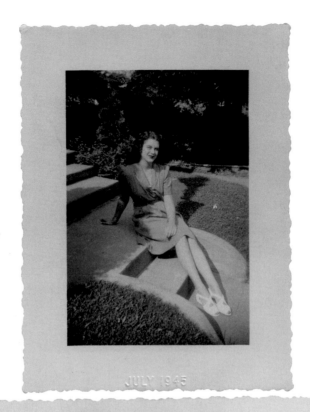

JULY 1945

Still waiting

1816

JULY 1945

60

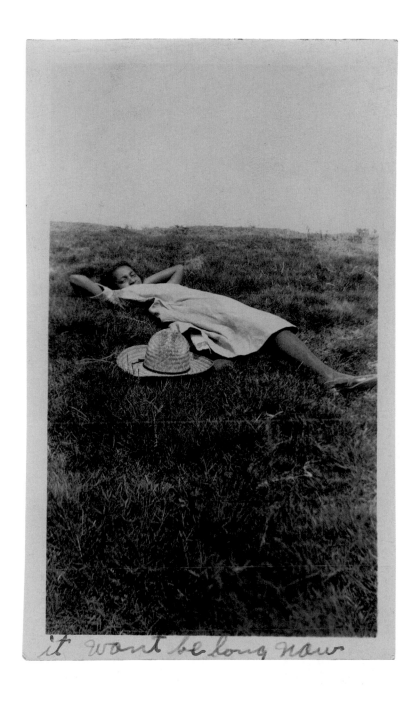

it wont be long now

61

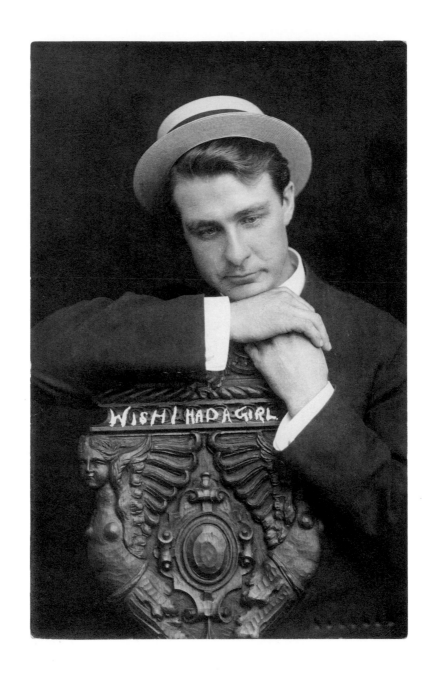

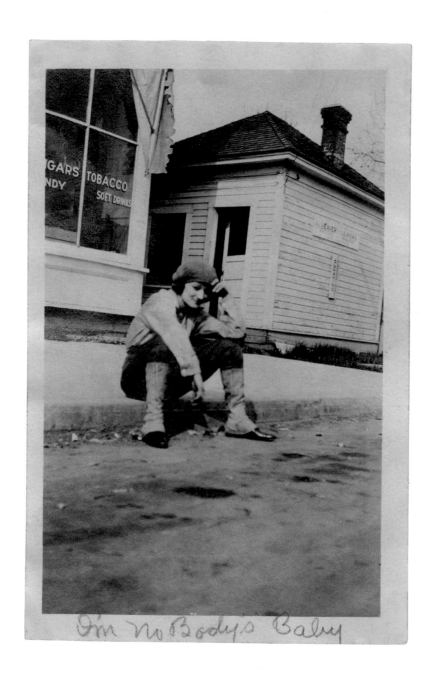

I'm Nobody's Baby

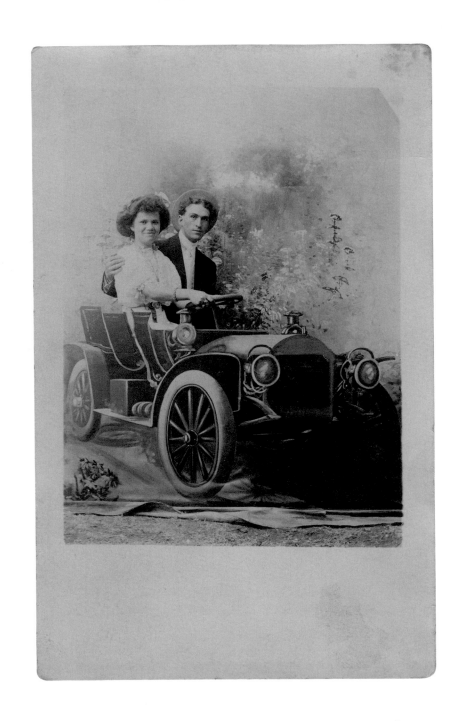

64

POST CARD

KRUXO
KRUXO · KRUXO
One Cent
Stamp
Here
KRUXO · KRUXO
KRUXO

THIS SPACE FOR MESSAGE

THIS SPACE FOR ADDRESS ONLY

Dear Marie,
keep this as a
rememberance
of a Discarded
Lover

65

Ms. Martha -
 My heaven and
my hell.

66

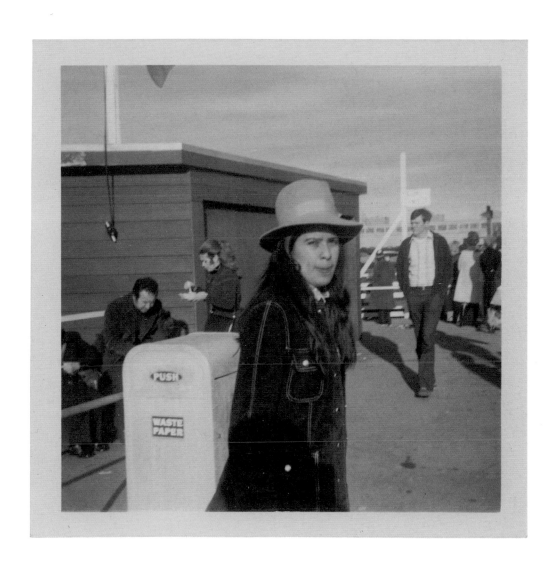

67

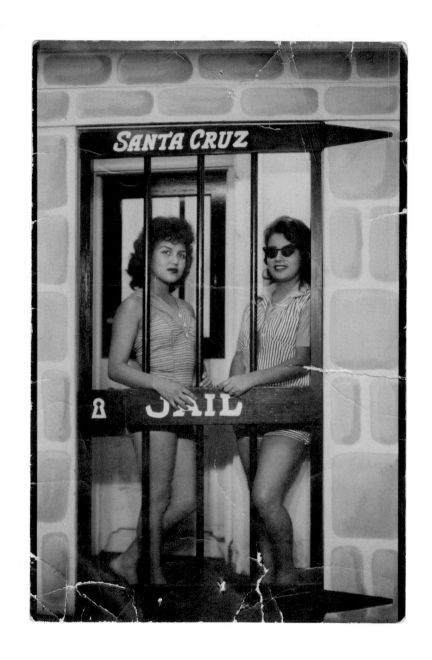

68

I'm through with all guys, all they do is hand you lies. They break your heart and make you cry, you want to drop somewhere and die. The way they treat you is a sin. wow.!!!!!!

Dig THAT guy THAT just walked in.!!!

I'M THROUGH WITH ALL GUYS. ALL THEY DO IS HAND YOU LIES. THEY BREAK YOUR HEART AND MAKE YOU CRY. YOU WANT TO DROP SOMEWHERE AND DIE. THE WAY THEY TREAT YOU IS A SIN. WOW!!!!!!! DIG THAT GUY THAT JUST WALKED IN!!!

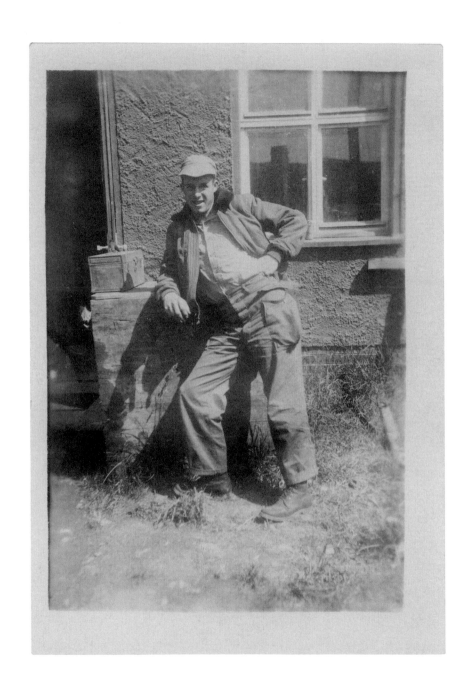

This is the barn.
Gloria is in love
with.

I think
I'll marry
this one

He's beautiful
and brings
out the best
in me.

73

74

My baby doll streching.
She's perfect Mom.
July '47

-Al

Isnt Life wonderful
when you are in love

928

We Met at the Lake
and finished at the
Preachers

78

79

Adams Bros

Ogden and Park City,
UTAH

80

this is Wellington Weebus who came to stay a week & buy my Father's Black angus bull named Alphonse III. he had advertised in Big Bull monthly. Wellington books passage by train back to Utah for him & the bull but wen he left he took my little sister Wilma age 15 along with the bull. Mama found a note in her room saying she loves Welby and will be wed to him in Provo and join his seven wives as sisters Mama crys daily and our church ladys try to comfort her to no avail. Papa says she is now too soiled to come back and claimes she would be hard to marry off and good ridance to her. His hope is that Wellingtons Bull check will clear the bank Boy is he Mad!!

Oscar didn't want to
give her away said
he wouldn't till 2
days before then
said he was going
to wear overhalls
+ straw hat and
carry a pitchfork.

1903

OSCAR DIDN'T WANT TO GIVE HER AWAY SAID HE WOULDN'T
TILL 2 DAYS BEFORE THEN SAID HE WAS GOING TO WEAR
OVERHALLS + STRAW HAT AND CARRY A PITCHFORK.

Junior Oscar Celia Jessie.

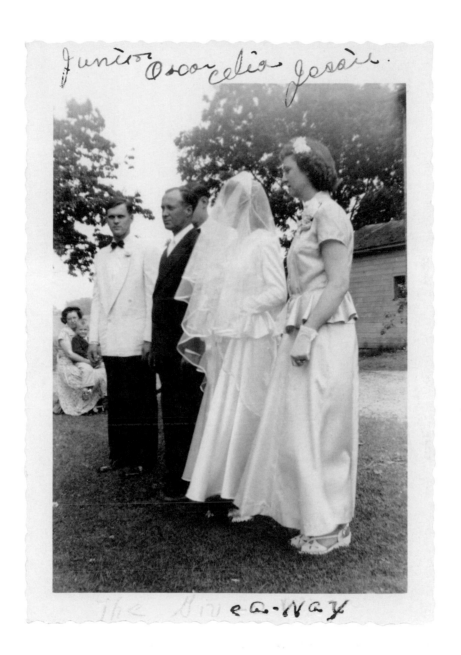

The Give-a-Way

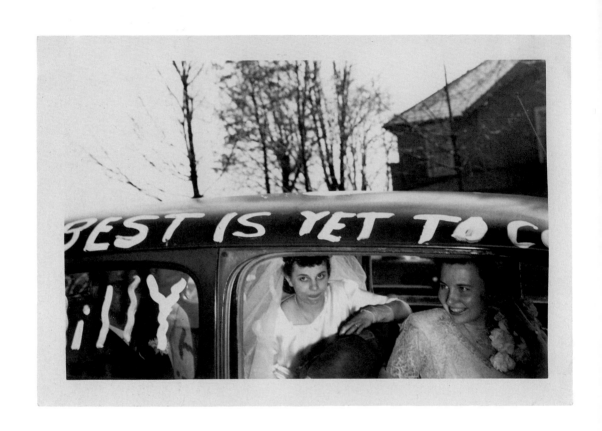

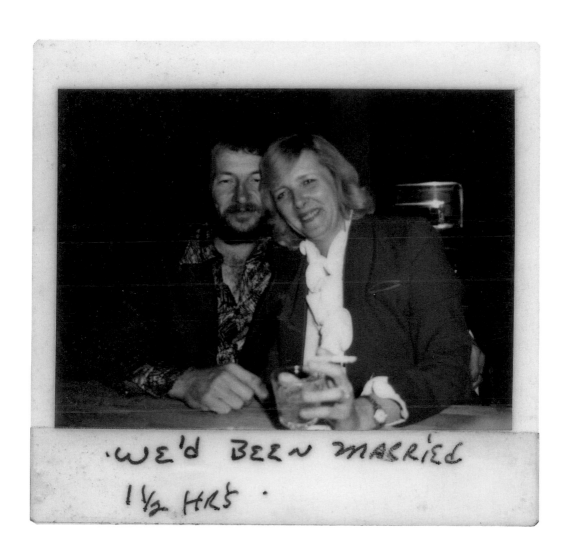

·WE'd BEEN married
1½ HRS ·

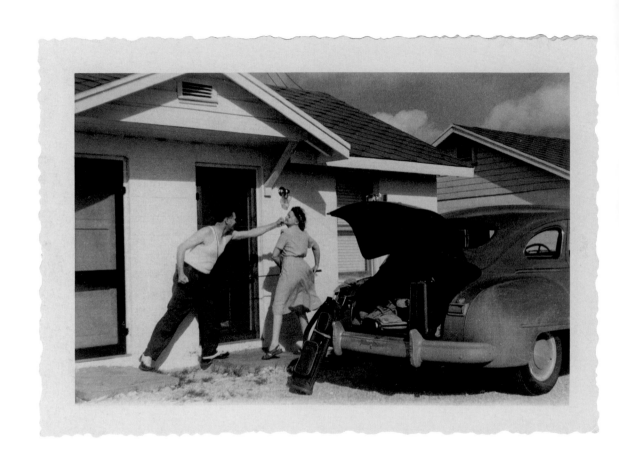

Did you say
Honeymoon ???

This is the way
my wife always
treats me.

I am saying to her—
"ah cut it out,"

1
α

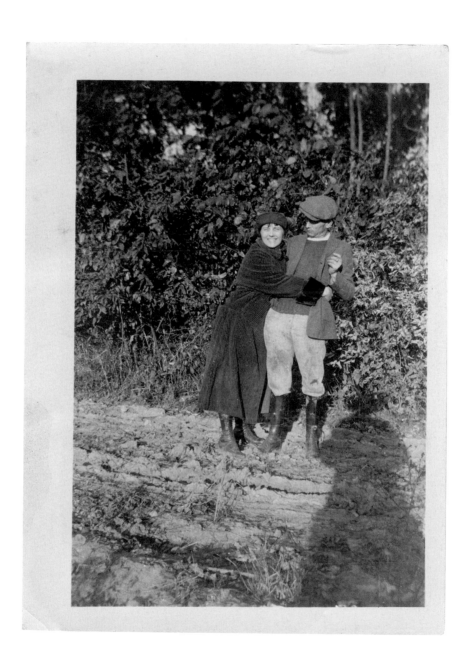

89

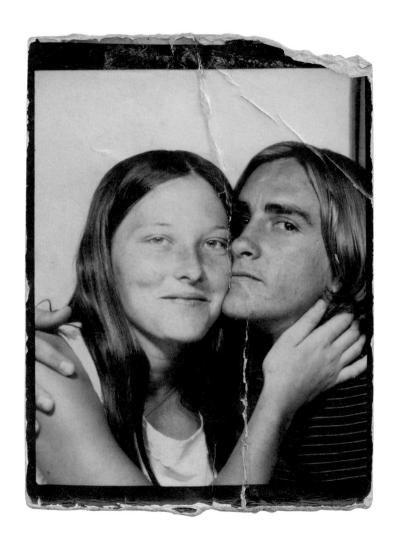

This was
when they
loved each
other

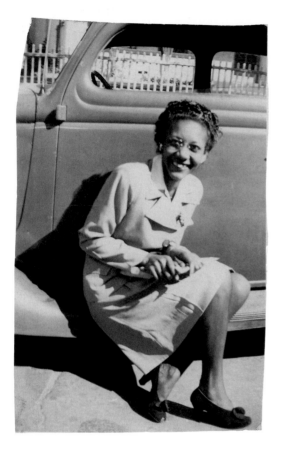

Were you
happy then,
baby?

I was.

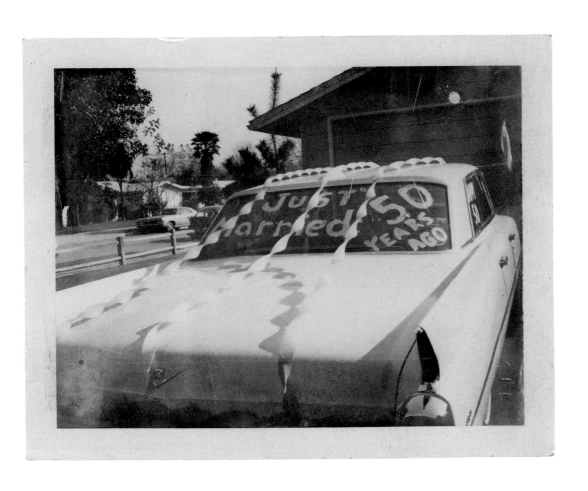

93

94

Taken the sunday
after our wedding

Two hearts that
beat as one

610K

TIMES OF TROUBLE

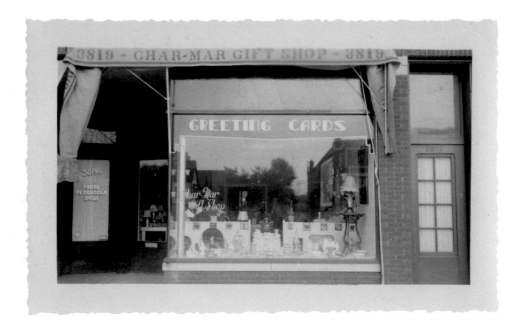

Our Store
Just a bad dream

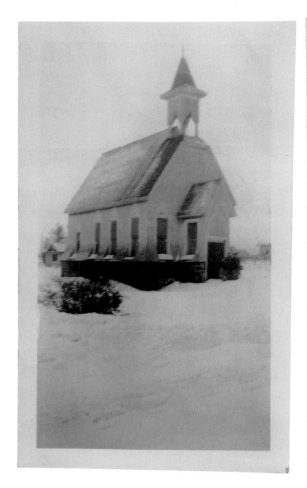

What a pity that this building couldn't be some place where it could be used.

Forsaken and forlorn it stands, while the movies, Pool and dance halls are crowded.

Church where we laboured for three months for our Lord and Master.

Doors closed because of the lack of finances.

One of my jobs
70 miles from home
I'd go anywhere
that I could make
a living Do you
know of anything back
there

ONE OF MY JOBS 70 MILES FROM HOME. I'D GO ANYWHERE
THAT I COULD TO MAKE A LIVING. DO YOU KNOW
OF ANYTHING BACK THERE?

Pearl with Freddie, Billie, Kenneth & Joyce at home in Lansing.

Moved to Detroit where Doris Jean & Elenore Ruth were born.
both died — Doris Jean at 11 mo. Spinal meningitis
Elenore Ruth at 4 mo. Malnutrition
NO $ for food

MOVED TO DETROIT WHERE DORIS JEAN + ELENORE RUTH WERE BORN.
BOTH DIED—DORIS JEAN AT 11 MO. SPINAL MENINGITIS
ELENORE RUTH AT 4 MO. MALNUTRITION
NO $ FOR FOOD

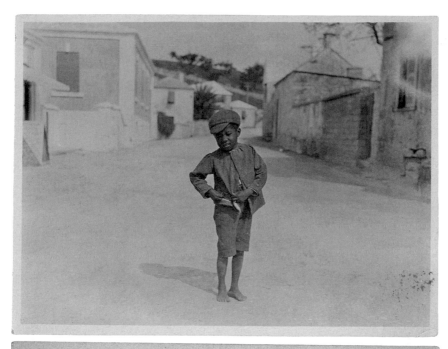

Little beggar
begging for
pennies, showing
he has none
Bermuda

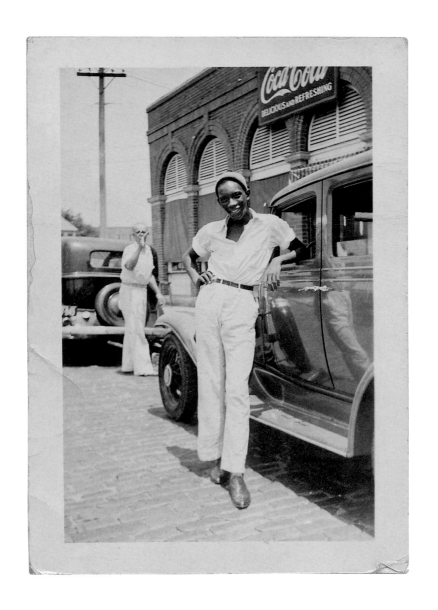

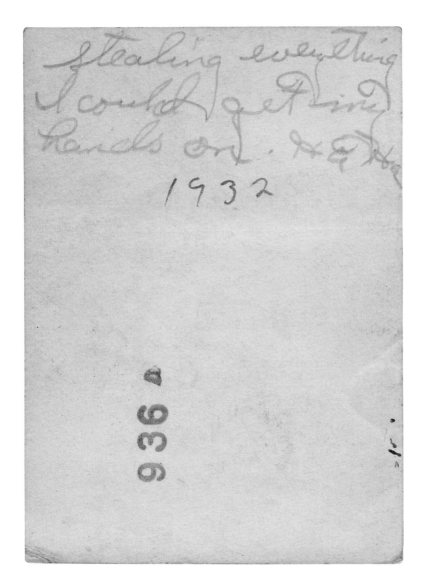

STEALING EVERYTHING
I COULD GET MY
HANDS ON. HA HA
1932

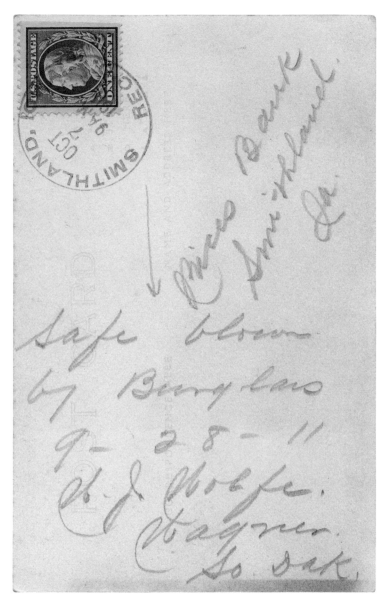

MILLS BANK, SMITHLAND IOWA
SAFE BLOWN BY BURGLARS 9-28-11
W.J. WOLFE
WAGNER, SO. DAK.

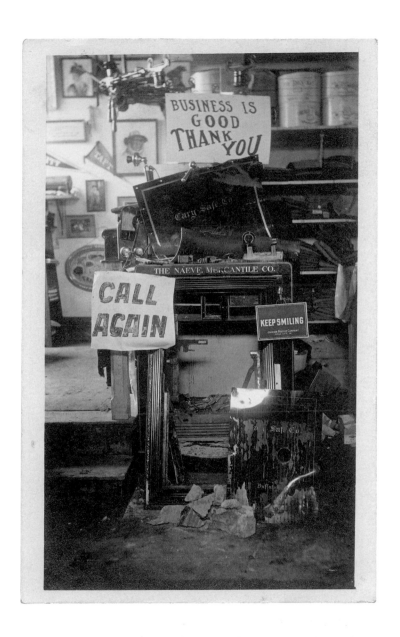

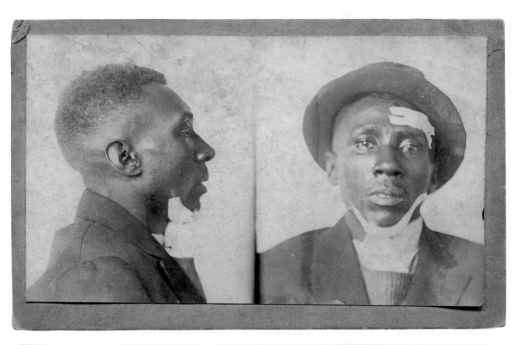

DEPARTMENT OF POLICE
LOUISVILLE, KY.
BUREAU OF IDENTIFICATION

	HEIGHT	HEAD LENGTH	L. FOOT
OUTER ARMS		HEAD WIDTH	L. MIDDLE FINGER
TRUNK		CHEEK WIDTH	L. LITTLE FINGER
		R. EAR LENGTH	L. FOREARM

FINGER PRINT 1 Ua 13
 1 Ua

REMARKS: _____

No. 5944

Name _Roy Smith_
Alias _____
Crime _M.a. Jail Breaking - D.C._
Age _32_ Height _5-11_
Weight _159_ Build _Slen_
Hair _Blk_ Eyes _Mar_
Complexion _M. Bro._ Moustache _____
Born _Ky._
Occupation _Teamster_
Arrested _1-21-24_
Received From _____
Sentenced _____

"Y AND E" ROCHESTER, N. Y. 2M 2-23 387512

P-79

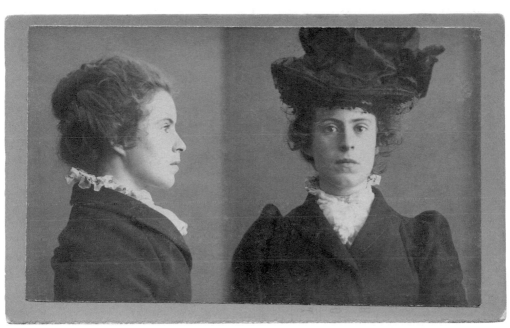

Name Fanue Mc Pherson
Alias
Crime Hotel Thief
Age 18 Height √ Ft. √ 3/8 In.
Weight 117 Build Slim
Hair Brown Eyes Blue
Complexion Med Moustache
Born U S
Occupation None
Date of Arrest June 18" 1899
Officer Lockwood + Sheehan
Remarks 22° Prect

Mole near right ear
Scar right wrist
" left thumb

Let's
hurry and
go get your
clothes so we
can come back here
and get loaded.

- 26/50 -

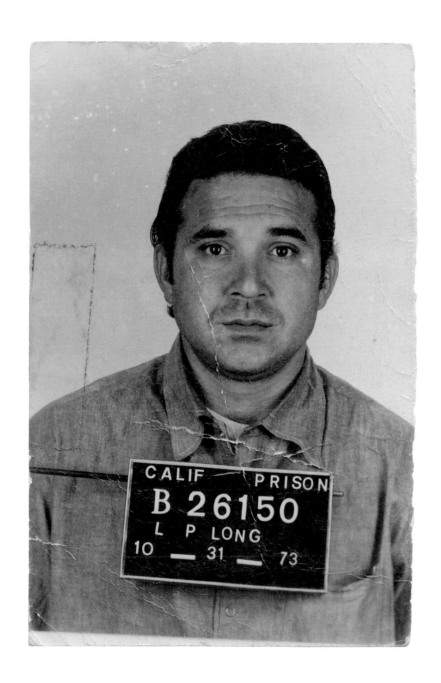

111

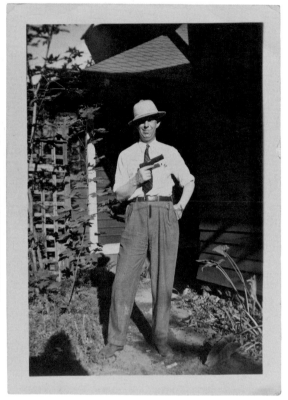

ME—THE SHERIFF.
JUST CAME IN FROM A MAN HUNT,
THE MAN STILL MISSING.
LEX
SUPER 38 AUTO NAMED SUSIE Q

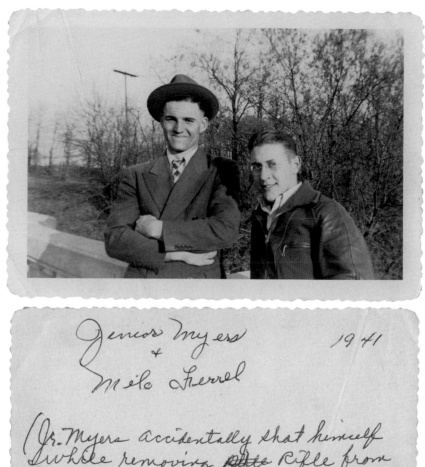

Junior Myers
&
Milo Ferrel

1941

(Jr. Myers accidentally shot himself
while removing ~~rifle~~ Rifle from
Car after return from hunting
trip.)

0448

(JR. MYERS ACCIDENTALLY SHOT HIMSELF WHILE REMOVING
RIFLE FROM CAR AFTER RETURN FROM HUNTING TRIP.)

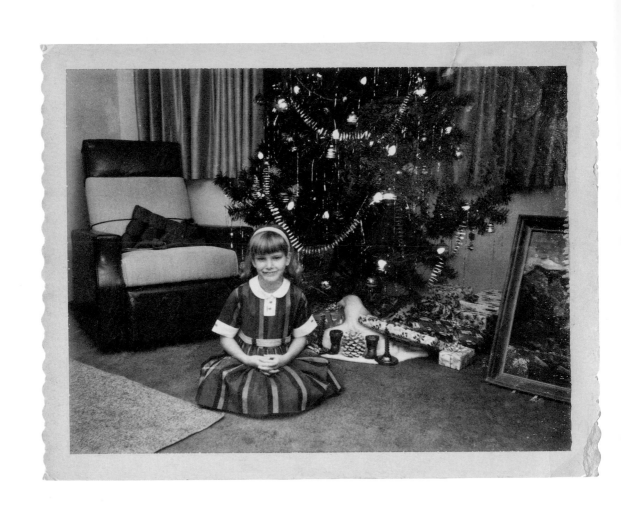

114

you can see Cecilia
cant smile to good
with stitches in her
lip

YOU CAN SEE CECILIA
CAN'T SMILE TO GOOD
WITH STITCHES IN HER LIP

H. Z. after a bee
sting in nostril

117

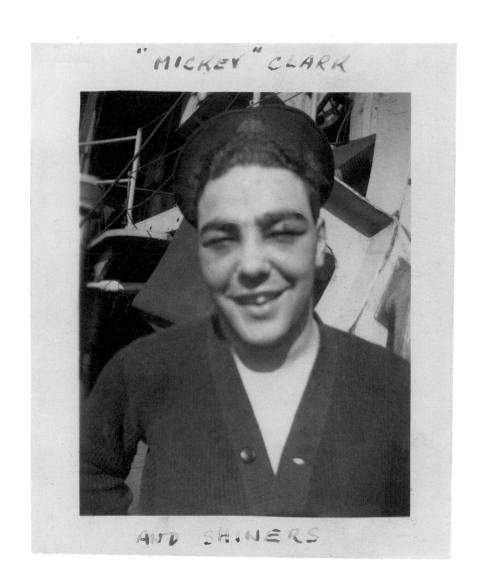

"MICKEY" CLARK

AND SHINERS

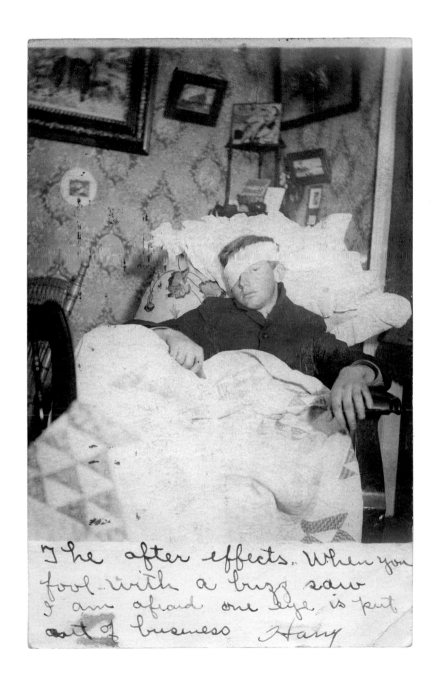

The after effects. When you
fool with a buzz saw
I am afraid one eye is put
out of business Hany

1922

The cat who
ate the fish hook.

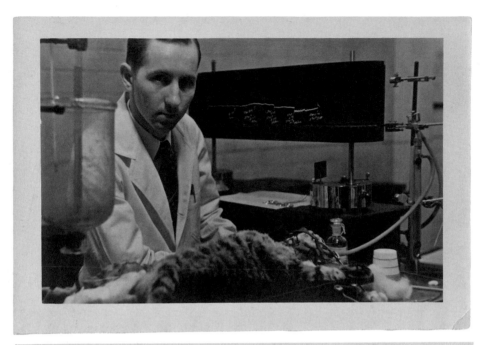

OPERATION
ON
THE
CAT

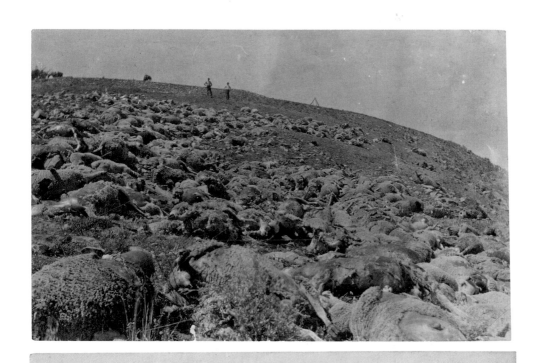

American Fork Canyon, Utah. Taken by
C. B. Arentson, July 27, 1918. 504 head of
sheep killed by lightning on July 22.

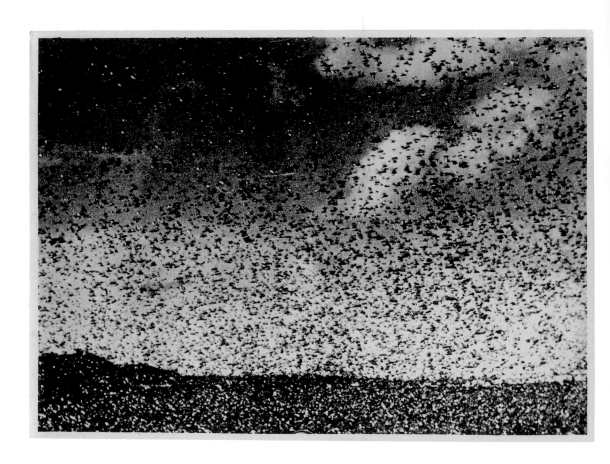

East Africa-Fall,1943

the locusts practically darken the sky.

6 2 3

When the storm hit
our place.

1945

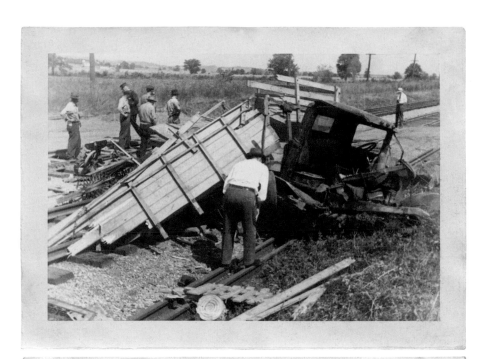

Train hit Mr. Kings truck.
1939.

793J

300' skid marks

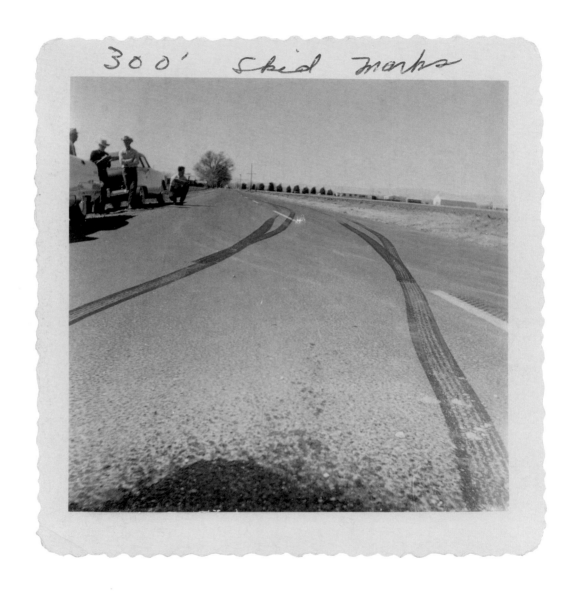

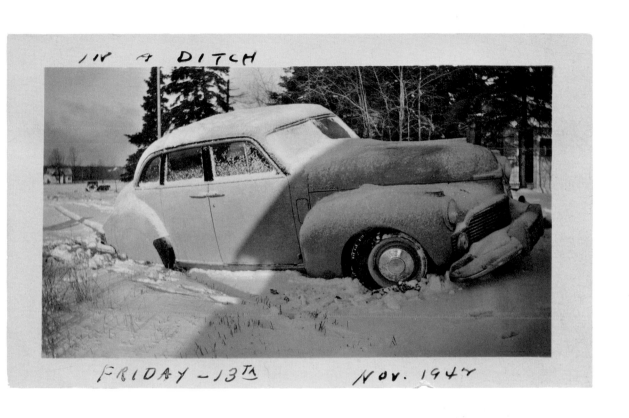

IN A DITCH

FRIDAY - 13TH Nov. 1947

You can put
this in your
scrap book &
remember how
much fun we had
teaching me how to drive

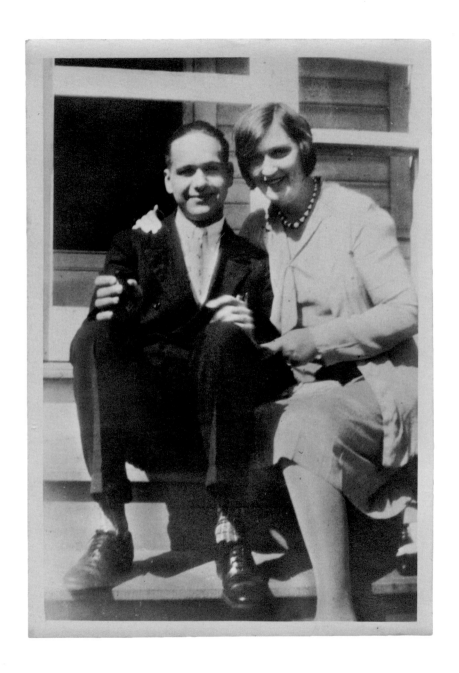

Ray & Polly Adams

↑

Butcher
at local
market

They were travelling by Auto
up the east coast of Florida
at night. Had a flat tire
and pulled onto the shoulder
to change it. They were hit
by another auto from behind
and Polly's leg was crushed.
Later amputated but gangrene
had set in and she could not
be saved.

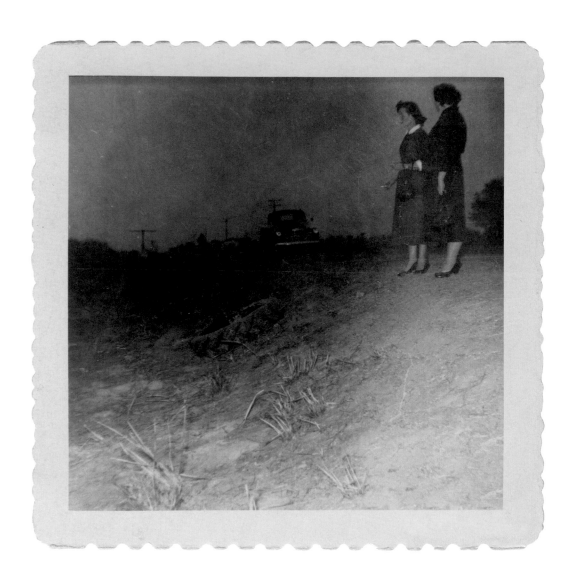

134

Mama & Grace — 1953
Where Daddy was killed

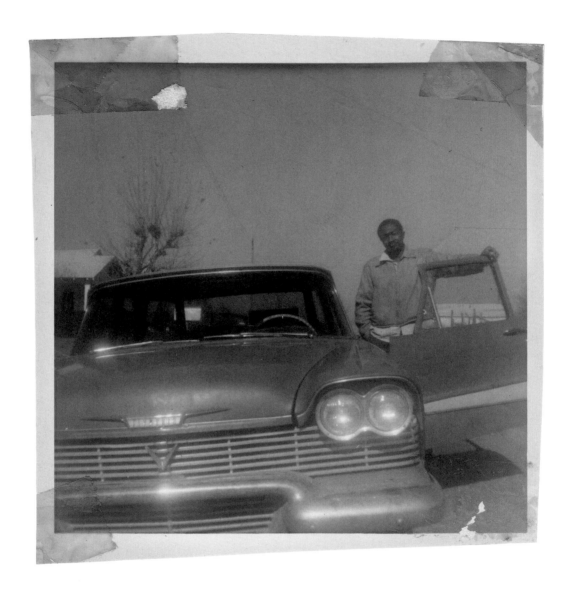

Chicken when he
was at death's door

Your
Daddy

This is a perfect picture of our daughter Marion - 27 - which Uncle Geo. took in Colo. Springs - about a month before she passed away

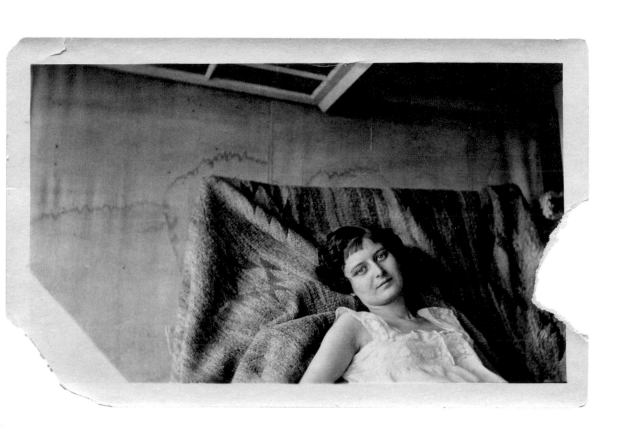

140

Grand mother brother
who fell from the dome
in the capital in D.C. and
killed himself he was a
carpenter, Grandmother
had 6 brothers who died

BACHRACH.

an unnatural death
it was very sad.
your Grandmother was
to young to know much
about it.

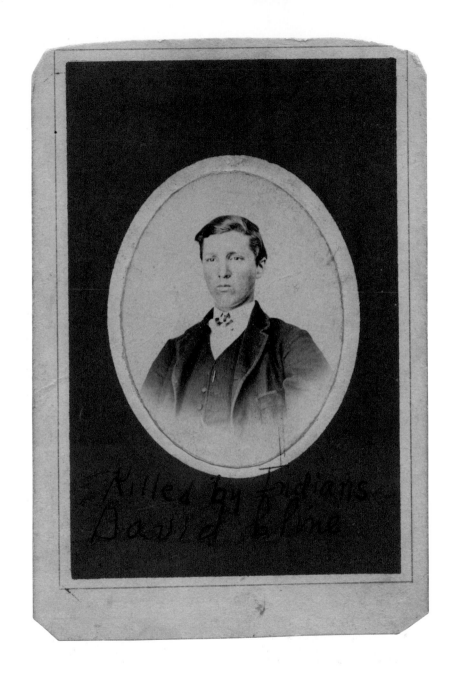

Killed by Indians
David Kline

142

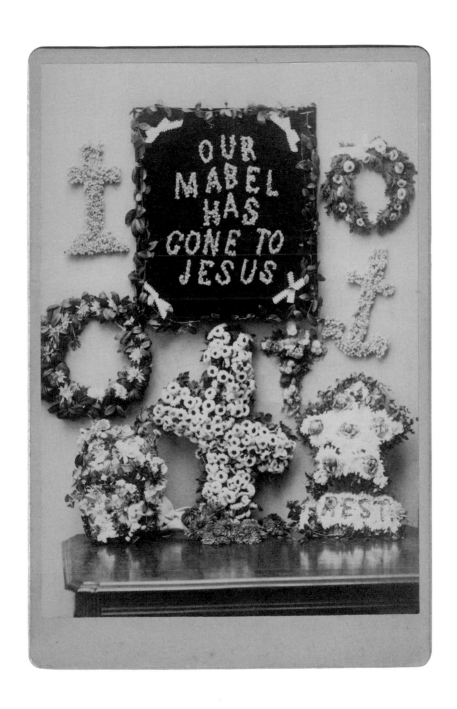

143

Jan 18–1917.

Just one year ago to day
you were here and I
wouldn't let you in the
house a year ago tomorrow
we were quarantined.
I thought perhaps you
had forgotten how beau-
tiful(?) we were at that
time so I am sending
these—"lest ye forget."

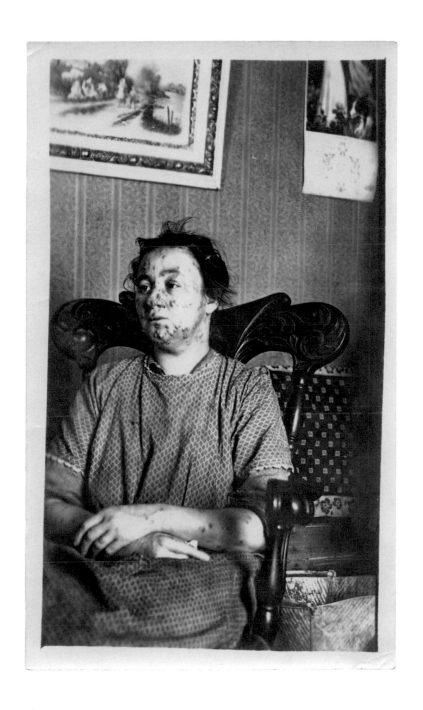

145

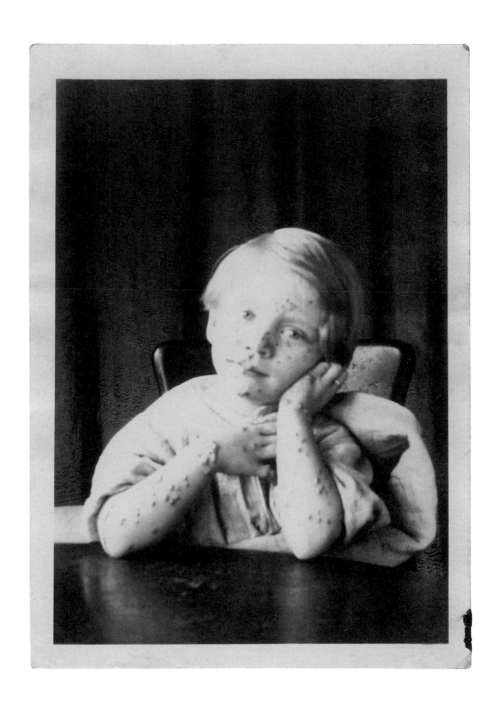

This was made
while Hazel was
sick with the
Smallpox

OH PLEASE EVERYBODY BE GOOD TO
POOR LITTLE SUSAN AND MY
DEAR BABY IF IT LIVES. OH MY
GOD HAVE MERCY ON MY CHILDREN
AND TAKE CARE OF THEM.
MAMMA DON'T EVER FORGET TO TELL
SUSAN TIME AND TIME AGAIN HOW I
LOVED HER AND LONGED TO LIVE TO RAISE HER.

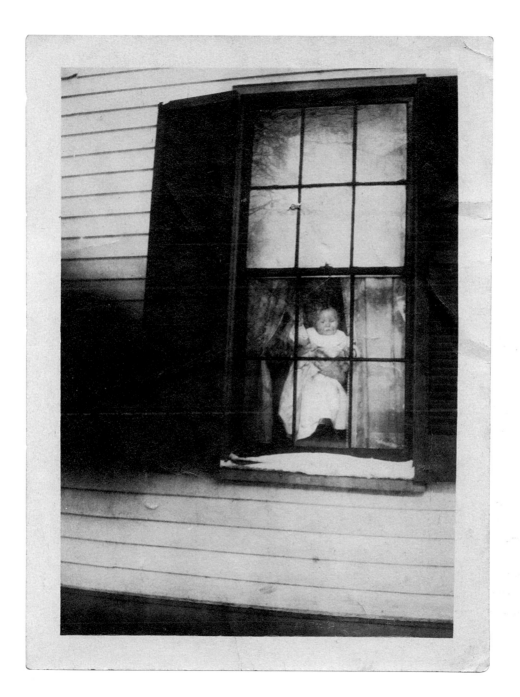

149

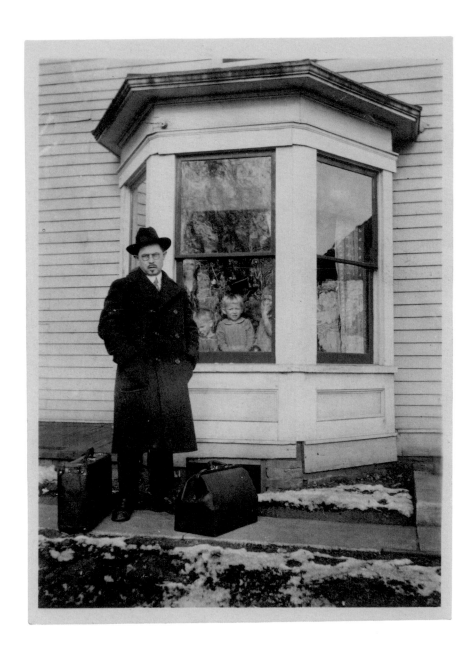

This is Elmer just
getting out of quarentine
before Xmas. He let
his beard grow till
the safety wouldn't cut
it, so had to go to the
barber shop looking like
this.

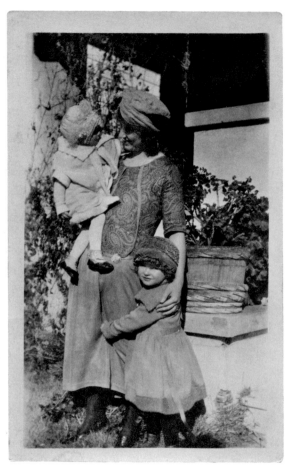

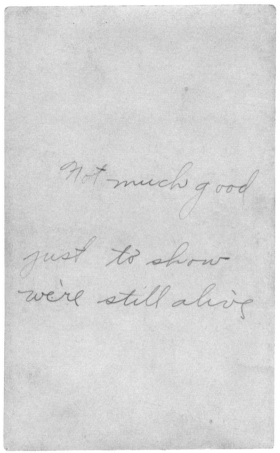

Not much good

just to show
we're still alive

Just
smilin through —
though it's
grim here
J—

153

154

1938
we got thru
the depression!

LIFE DURING WARTIME

leaving home for war

I have pictures of
First day to school
First day to high school
First day to college
 and
First day off to war.
This one I could
easily & gladly have
done without

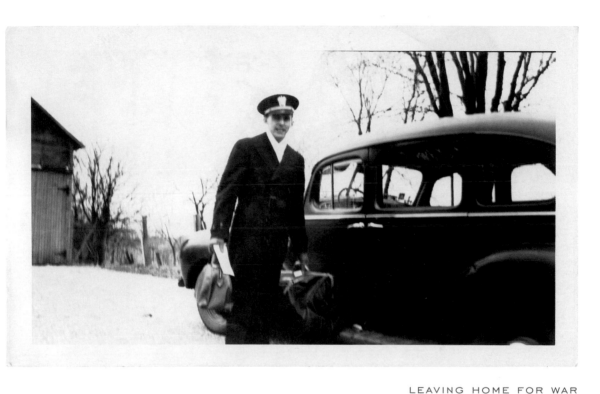

LEAVING HOME FOR WAR
I HAVE PICTURES OF
FIRST DAY TO SCHOOL
FIRST DAY TO HIGH SCHOOL
FIRST DAY TO COLLEGE
AND
FIRST DAY OFF TO WAR.
THIS ONE I COULD
EASILY + GLADLY HAVE
DONE WITHOUT

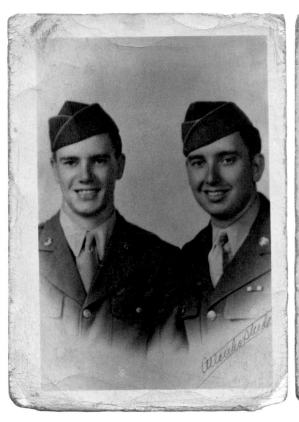

The pride of
my life.
God Bless Them
& return them
safely to us.

met – July – 18
steady – July – 25
engaged – aug – 5
marry – aug – 29
enlist M. – Oct – 9
sworn – Oct – 16
left – Oct – 19 69
home – Nov. 16
left – Nov. 30 – 26 N. Virg
called – Dec. 28 – Trinidad
had Jan. 6 – 40.00
spent: 5.00 Thurs.
spent 10.00 Fri. – at.
sund 10.00 sund. + 5 to him 2.00

last shot of the States
sure hope like hell i'll
be seeing this again soon.

march, 1951

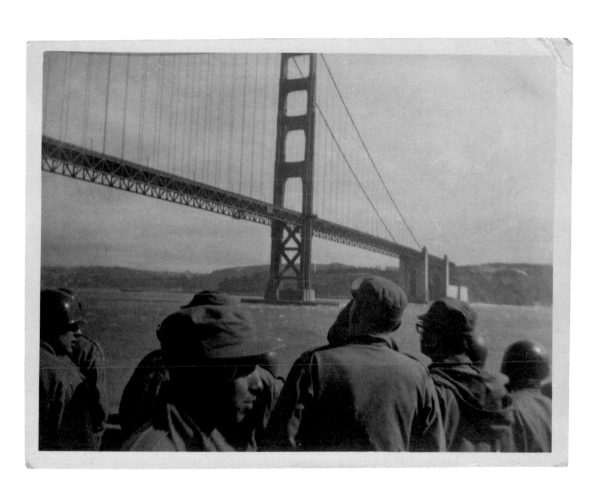

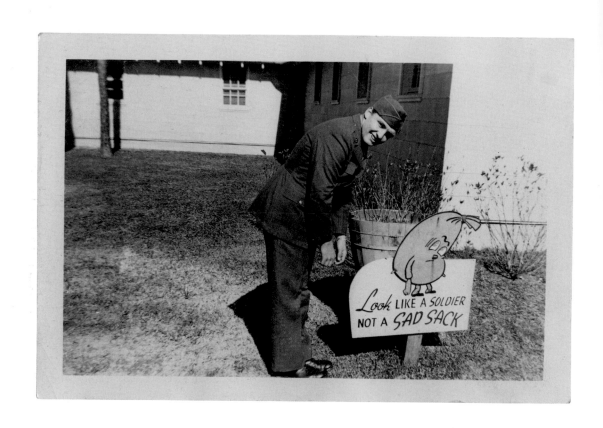

164

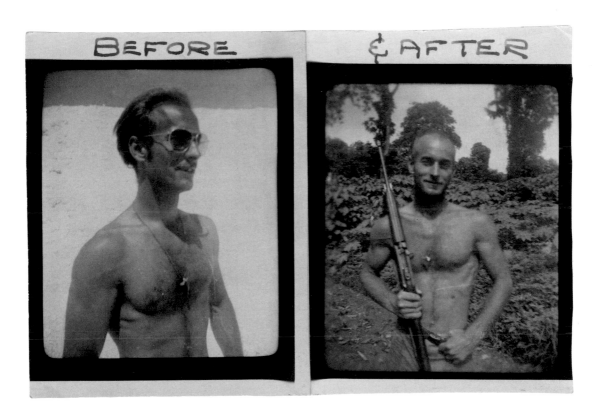

BEFORE &AFTER

165

Tom doing A little SACK Time

167

Never a dull moment

108

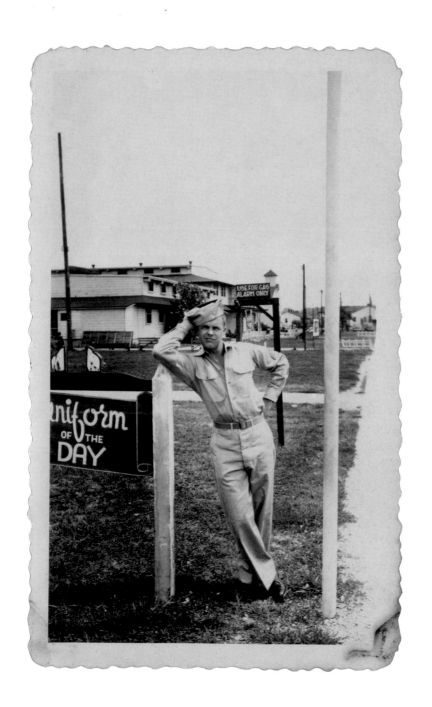

ROBERT AT MAILCALL
WHEN THERE IS NO
LETTER FROM MOM.

NOTICE THE GENERAL
DISPIRITINESS - THE GATHER-
ING TEARS - THE SLACK
LIPS. FROM MY TRAINING
AS A COMBAT MEDIC
I WOULD DIAGNOSE THIS
A NO-LETTER-FROM-MOM
FATIQUE. THIS CONDITION
IS VERY SIMILAR TO
COMBAT FATIQUE.

five jerks

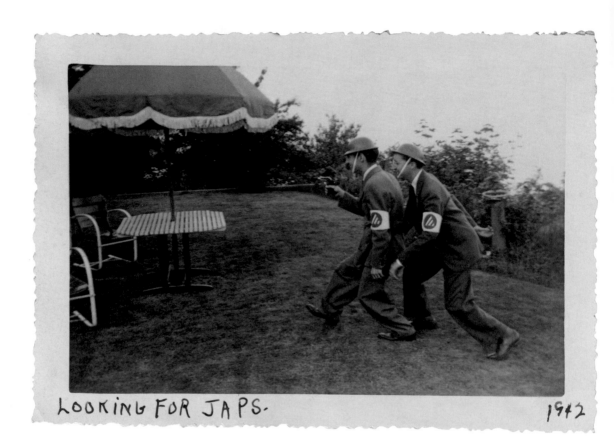

LOOKING FOR JAPS. 1942

172

Flying lead for the Japs!

Love Don

"Jew" Store

Closed

174

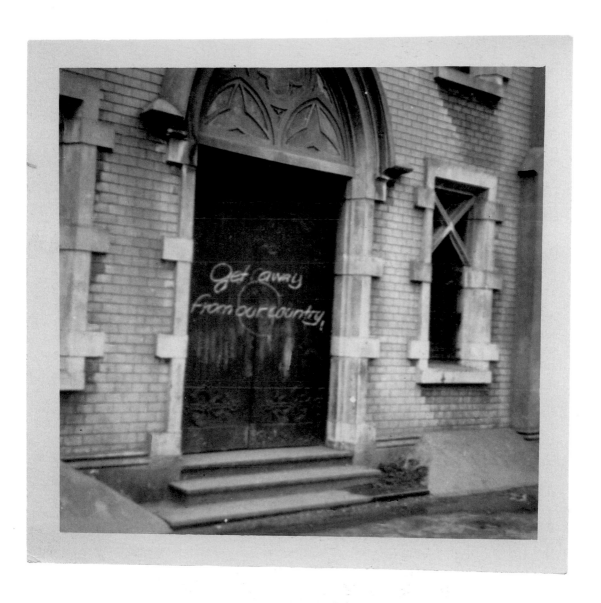

175

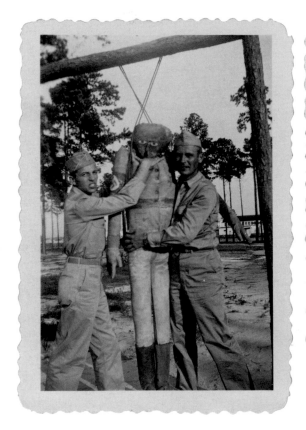

Protecting the madman of Berlin from the murderous wrath of Meyer the Magnificent

PROTECTING THE MADMAN OF BERLIN
FROM THE MURDEROUS WRATH OF
MEYER THE MAGNIFICENT

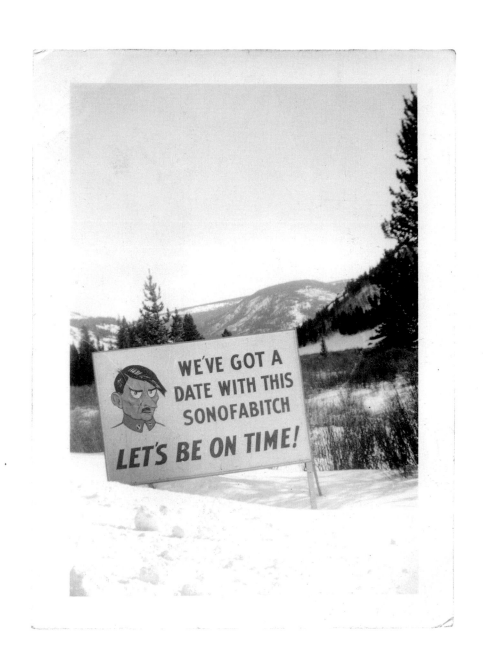

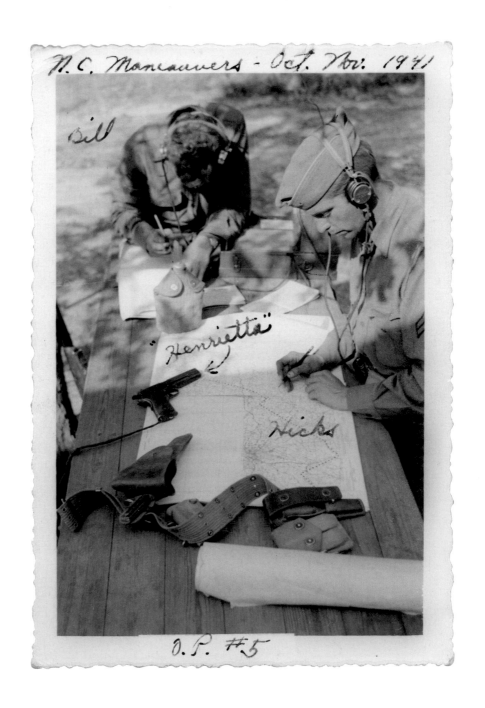

N. C. Maneuvers - Oct. Nov. 1941

Bill

"Henrietta"

Hicks

O. P. #5

178

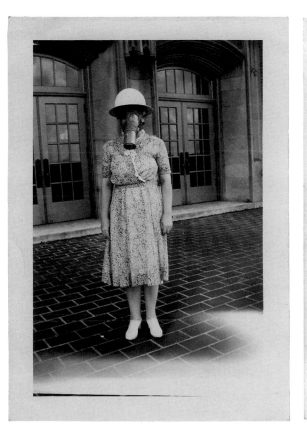

Miss Hicks in
her air raid
outfit

MISS HICKS IN HER AIR RAID OUTFIT

This is the sign
that designates me
as the block
mother!

77

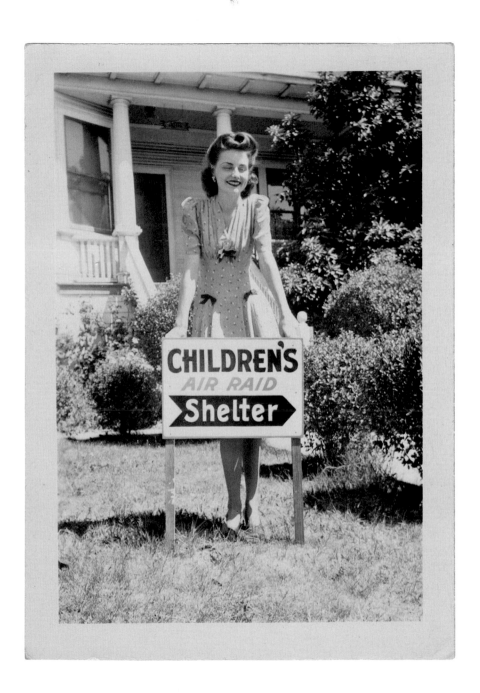

This was our home for
a few weeks.

Korea
1951

This is the
way girls look
at the Whore
houses

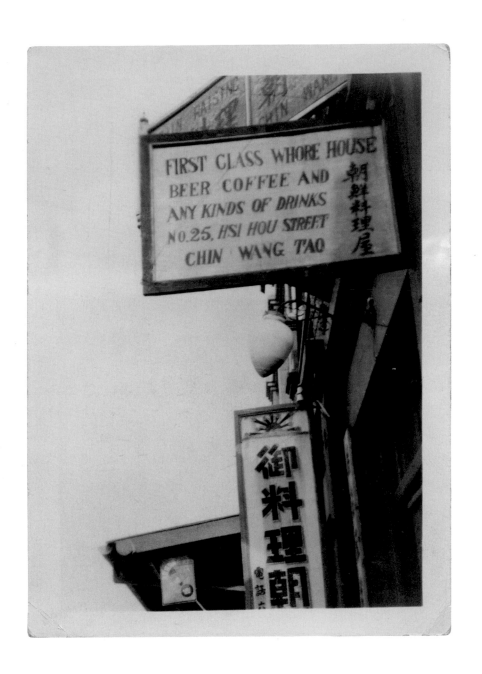

FIRST CLASS WHORE HOUSE
BEER COFFEE AND
ANY KINDS OF DRINKS
NO.25, HSI HOU STREET
CHIN WANG TAO

朝鮮料理屋

御料理朝

184

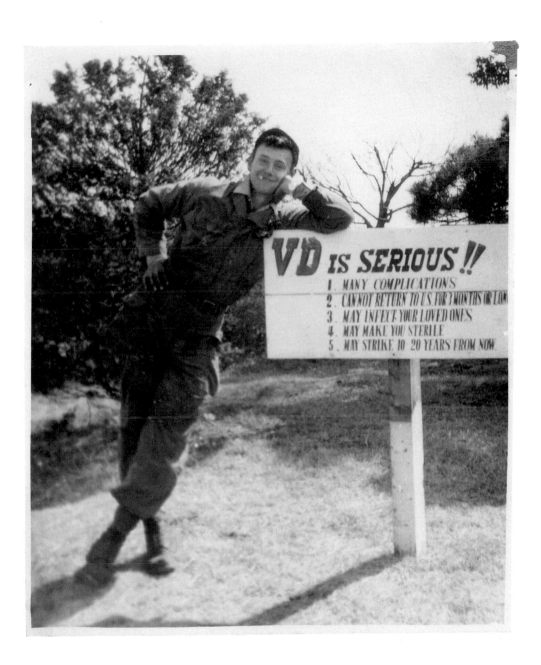

VD IS SERIOUS !!
1. MANY COMPLICATIONS
2. CANNOT RETURN TO U.S. FOR 3 MONTHS OR LON
3. MAY INFECT YOUR LOVED ONES
4. MAY MAKE YOU STERILE
5. MAY STRIKE 10 - 20 YEARS FROM NOW.

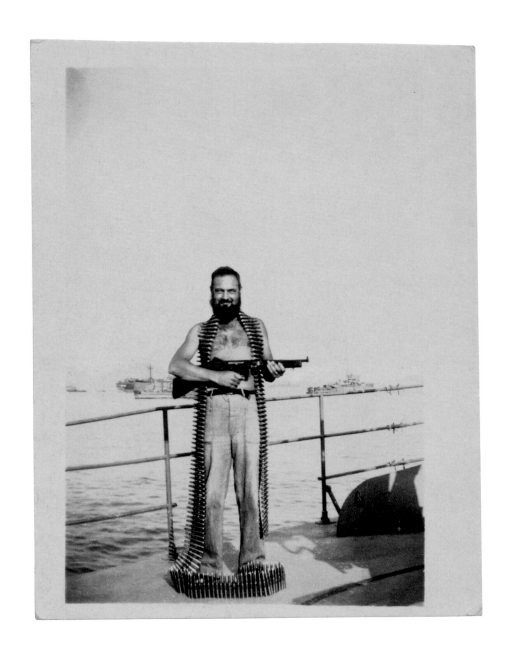

Geo on board ship
at Pearl Harbor.

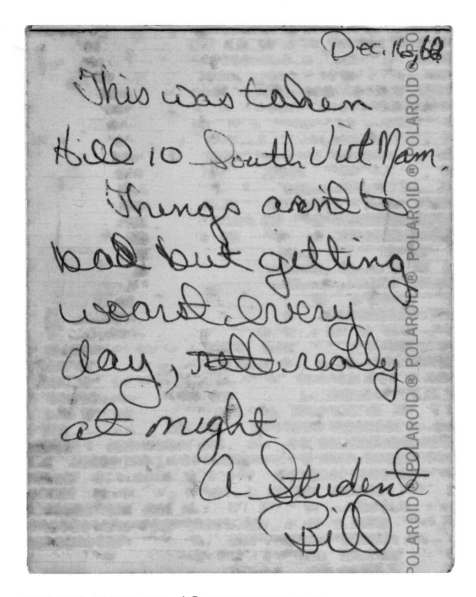

THIS WAS TAKEN HILL 10 SOUTH VIET NAM.
THINGS AREN'T TOO BAD BUT GETTING WORST
EVERY DAY, REALLY AT NIGHT
A STUDENT
BILL

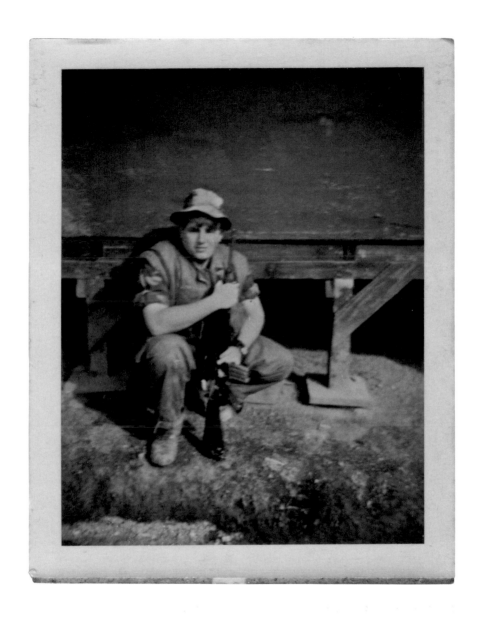

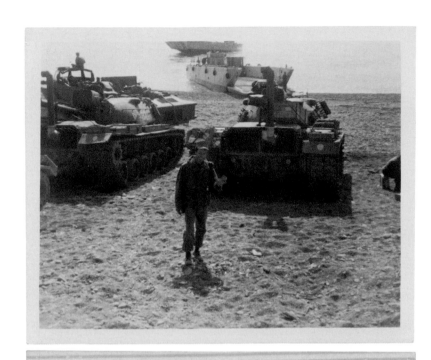

I WAS FREAKING OUT

5607

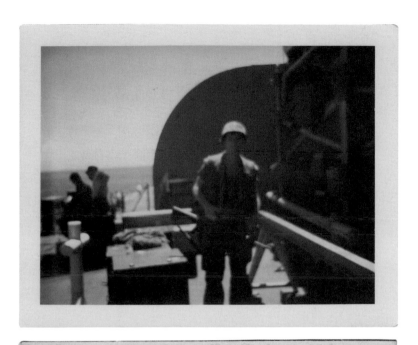

Morning After Night
Ambush
8 gooks KIA.
US - 4 KIA, 1 wounded

Aug 27, 1969

the ones on the left
and right got killed
when I got hurt.

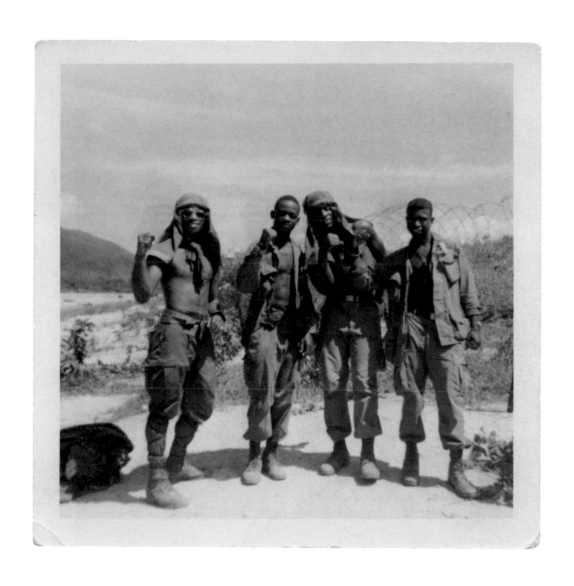

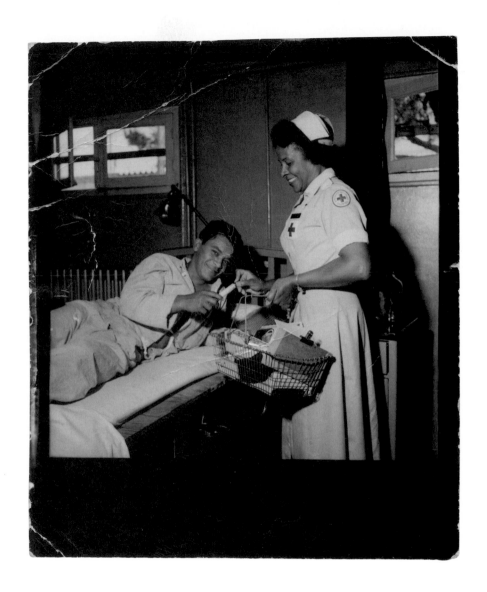

Dear Betty —
yours truly
working as a
"Grey Lady" for
our American Red
Cross at our
hospital here
at Bussac, France

Aldita

195

14 pills, tablets every 2 hours,
day AND NIGHT!
Espiritu Santo; feeling good
after release from hospital,
but ribs are evident. (Had
"acute gastroenteritis")

and

"SINUSITIS, PAROTITIS, SIALADENITIS,
CERVICAL ADENOPATHY-anterior
auricular, anterior cervicular"

and....
 operation
 5 "HYDROCELECTOMY"!
 0
 1

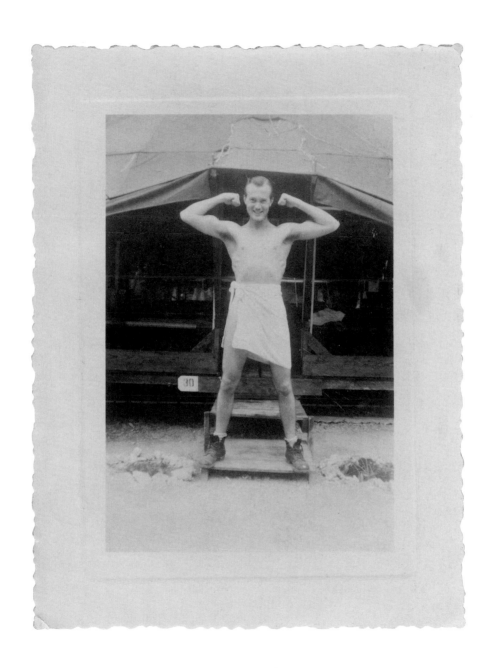

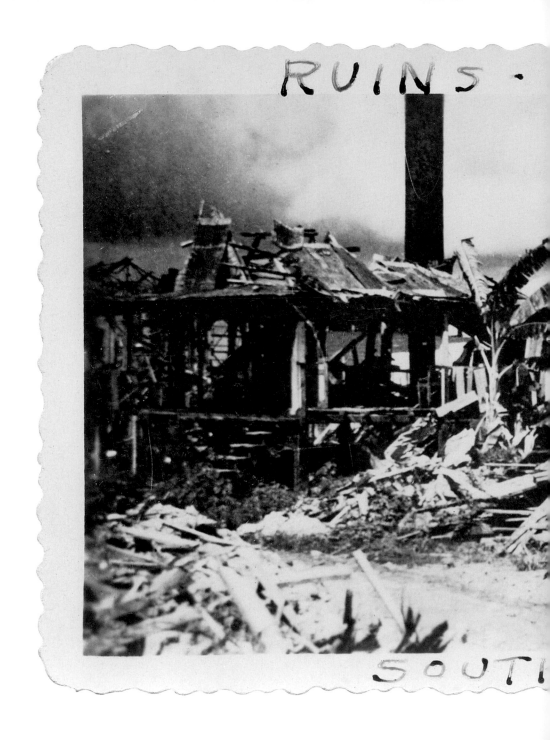

RUINS.

SOUT

198

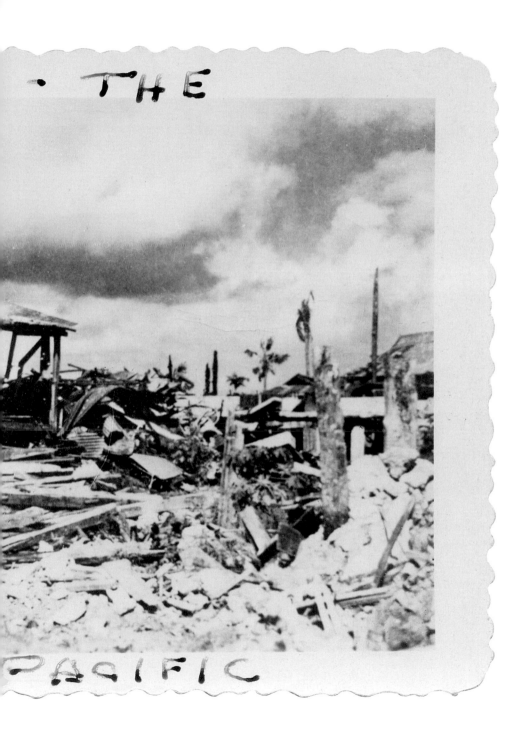

THE

PACIFIC

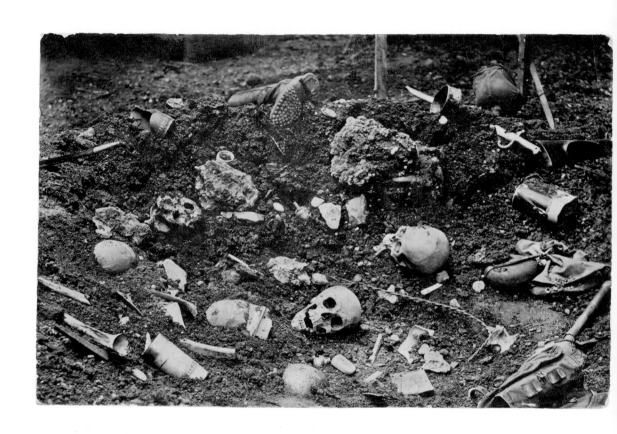

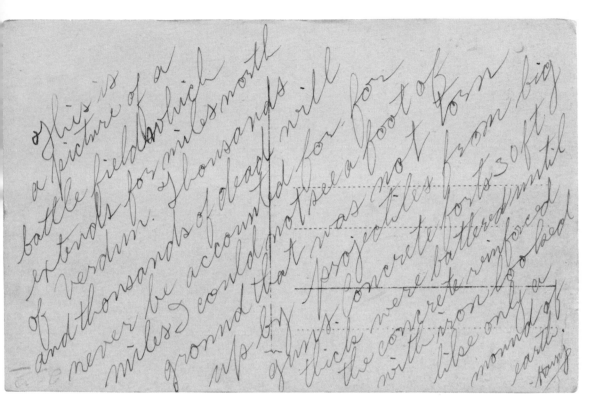

THIS IS A PICTURE OF A BATTLE FIELD WHICH EXTENDS FOR
MILES NORTH OF VERDUN. THOUSANDS AND THOUSANDS OF
DEAD WILL NEVER BE ACCOUNTED FOR. FOR MILES I COULD
NOT SEE A FOOT OF GROUND THAT WAS NOT TORN UP BY
PROJECTILES FROM BIG GUNS. CONCRETE FORTS 30 FT
THICK WERE BATTERED UNTIL THE CONCRETE REINFORCED
WITH IRON LOOKED LIKE ONLY A MOUND OF EARTH. HARRY

An American Distroyer
that met us I day from Franc
to convoy us safely through
the submarine zone. Snapped
from my stateroom porthole.

"CHARLIE" PIER THE LAST
FEW YARDS TO THE SHIP

WONT BE LONG TILL I WALK
UNDER THAT WONDERFUL SIGN

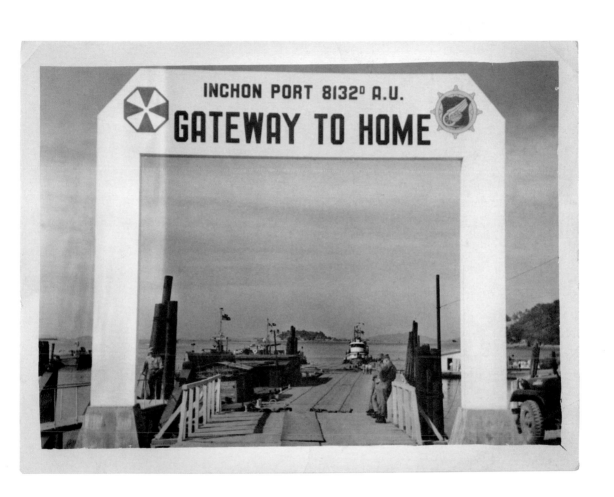

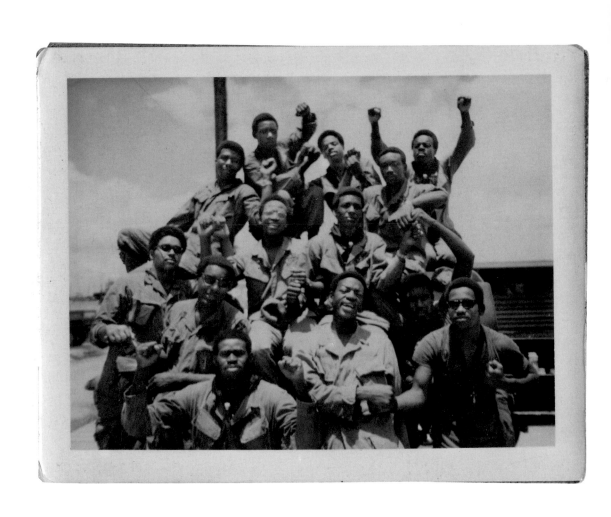

me and all my Brother
we just got back from
Cambodia and boy we
are happy.

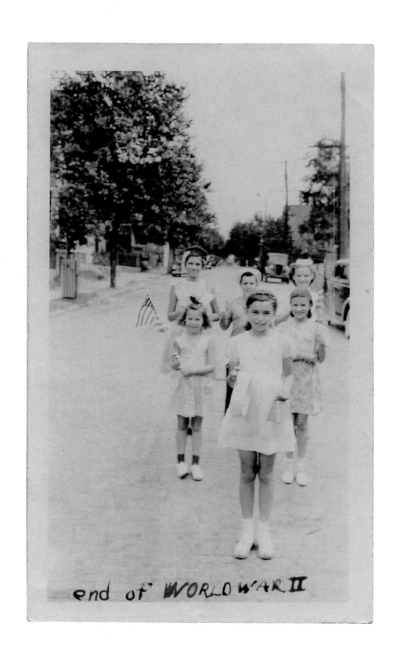

end of WORLD WAR II

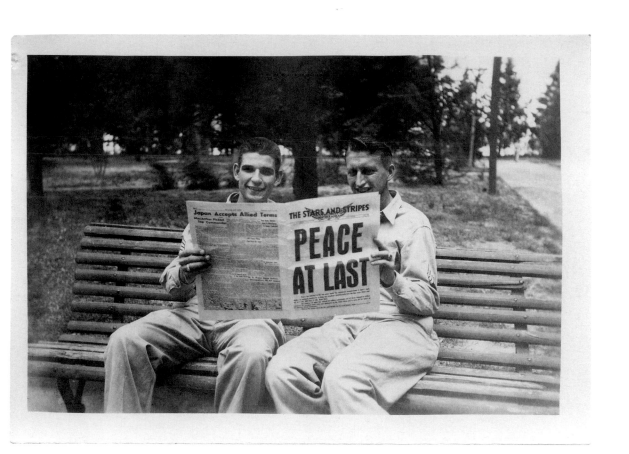

209

I am
pointing to my
Discharge
Button

Feb 24 '46

211

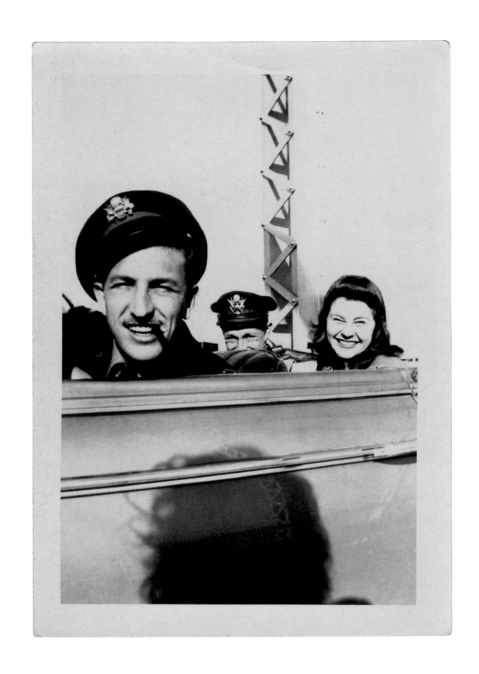

Thats a cigar in my mouth

114

Seeing is believing.

024

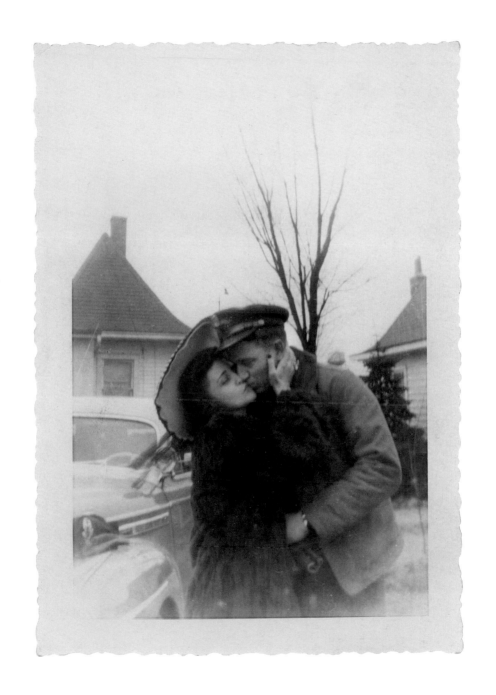

215

A liberation dance given
for the natives by the
Sea Bees. Jitterbugs!

Pearl Harbor

216

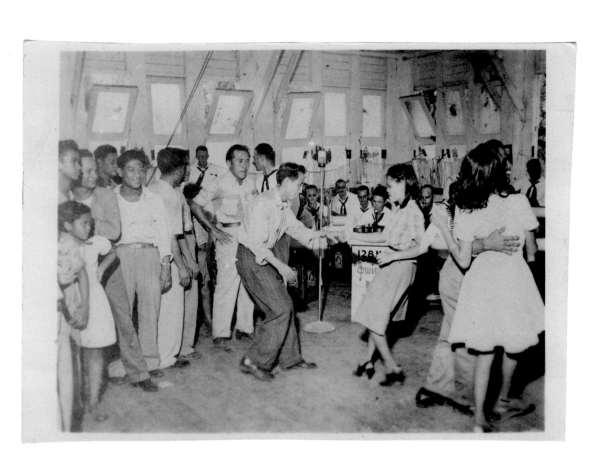

217

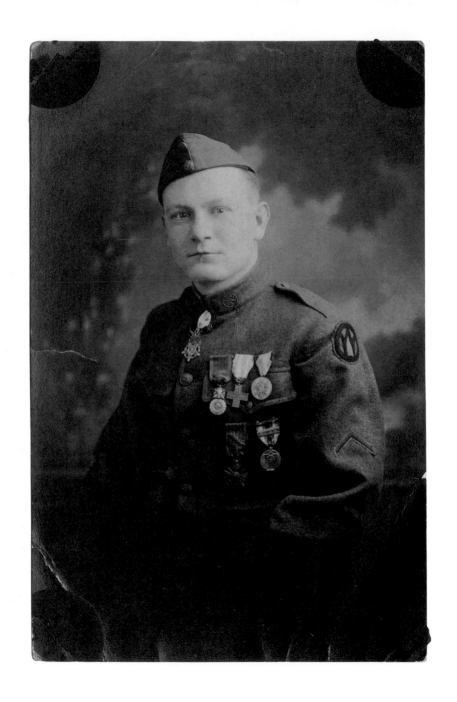

218

From Harold to Billie

POST CARD

CORRESPONDENCE

▲ ▲ Z O ▲
▲ PLACE ▲
Z STAMP Z
O HERE O
▼ ▲ Z O ▼

ADDRESS

*He says for you to show
this to the Leathernecks and
tell them from the looks
of these medals they
did not altogether won the
war.*

FROM HAROLD TO BILLIE

HE SAYS FOR YOU TO SHOW
THIS TO THE LEATHERNECKS AND
TELL THEM FROM THE LOOKS
OF THESE MEDALS THEY
DID NOT ALTOGETHER
WIN THE WAR.

219

American soldiers
that came back
from Jap prison
camps in Bataan.
The first ones
to come back.
Taken in San
Francisco, on March
12, 1945

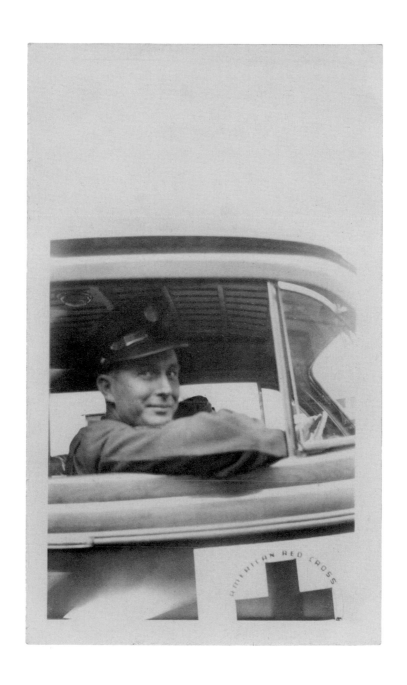

Dachau, Germany
May 1945
Box-cars at entrance
to notorious concentration
camp –

222

224

Sept 45.

Big Dog kennels at
Dauchan camp.

These dogs used
to be set on
the prisoners
and bitten until
they died.

Dachau, Germany.

2 - SS men murdered
by camp prisoners

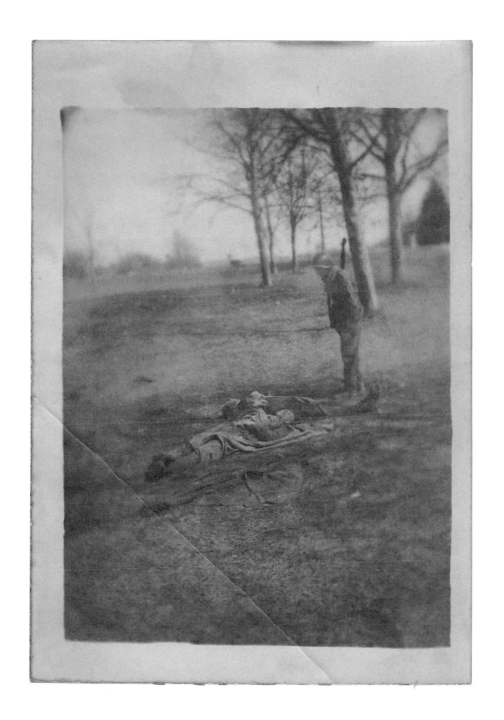

John in front
of house

1918 - Valenteered for World War 1
133 field artirraly - was a crack
shot - Served in France -
Returned Home - 1919 - a mental wreck

JOHN IN FRONT
OF HOUSE
1918—VOLUNTEERED FOR WORLD WAR I
133 FIELD ARTIRRALY—WAS A CRACK
SHOT—SERVED IN FRANCE.
RETURNED HOME—1919—A MENTAL WRECK

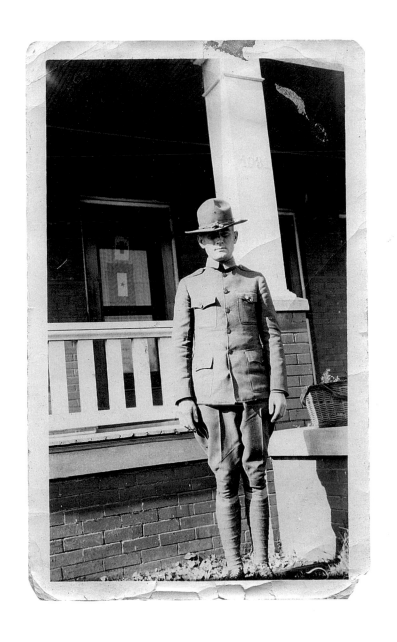

229

Scotty was killed
on the Bunker hill.
Hey would have been
Married

157

231

232

1945

Roy Trahl.

Killed in

Action —

Luxembourg

Jan. 1945

1934

Bought in Billfold and carried all my Navy career & long afterwards as a good luck Charm, put in albym to save & keep with all my keepsakes

234

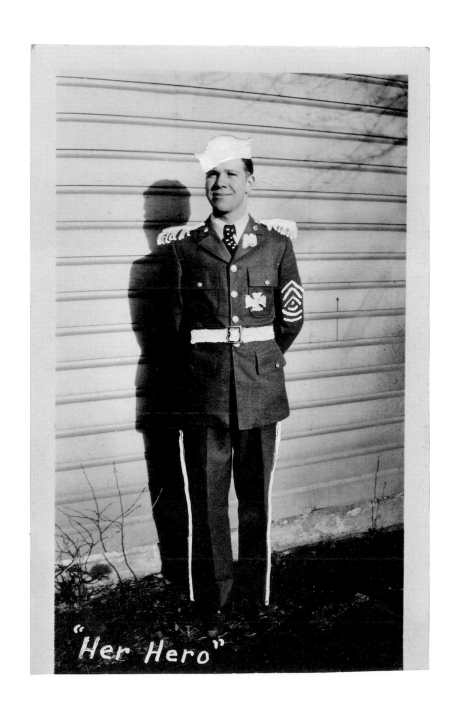

"Her Hero"

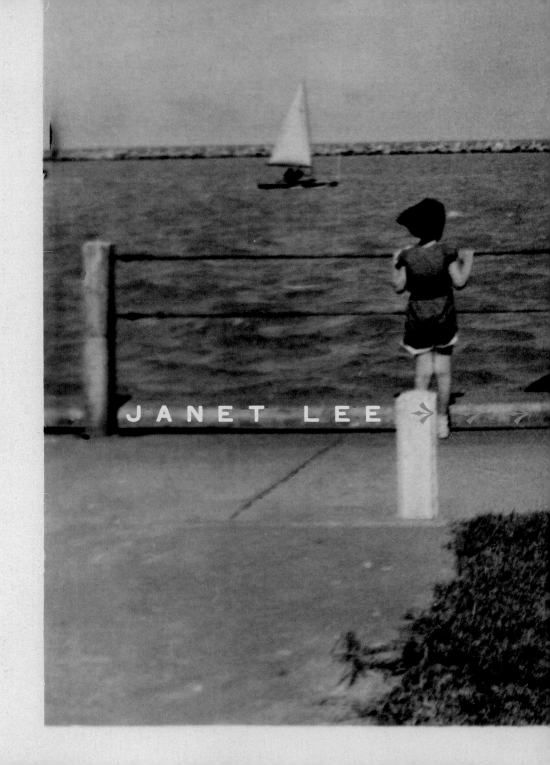

JANET LEE

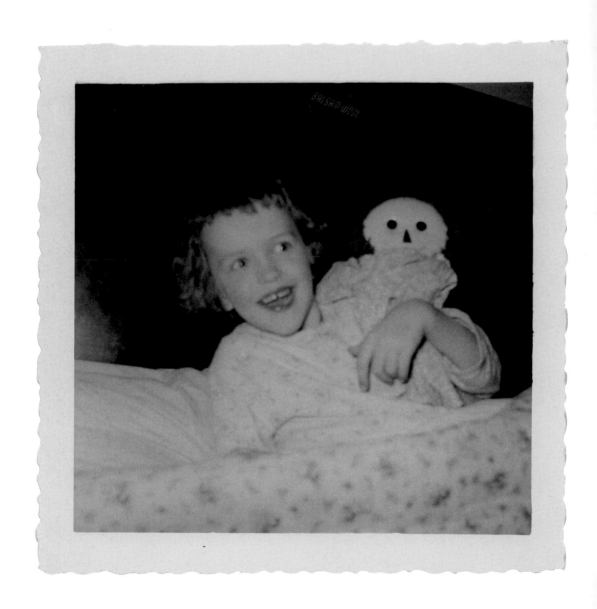

238

JANET LEE
AND
RAGGEDY ANN
READY FOR
BED
MAR. 1955

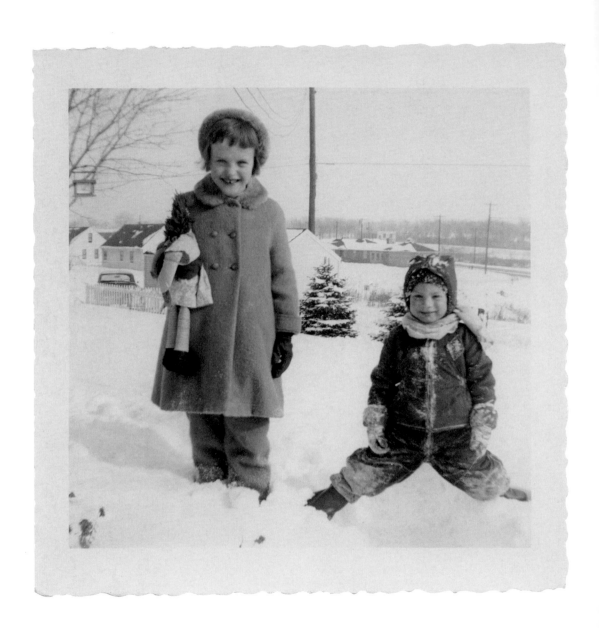

240

JANET WAS SO
PLEASED TO SEE
MARK OUTSIDE
THAT SHE DECIDED
TO GO OUT AND
PLAY.

JANET
GOT A
PERMANENT
$7.50

JANET LEE
IN
HOSPITAL
JUST BEFORE
GOING FOR
HER (X-RAYS)
TEST

G418

243

HAROLD
AND
JANET,

H 380

HAROLD WORRIES
A LOT ABOUT JANET
— HIS ULSER
ACTS UP NOW AND
THEN —

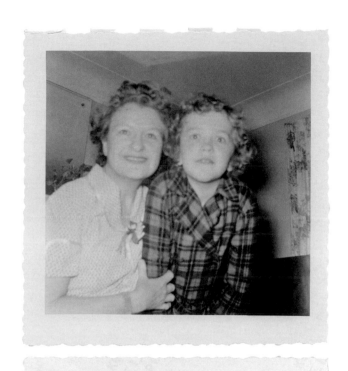

JANET
AND I
POSING FOR
YOU

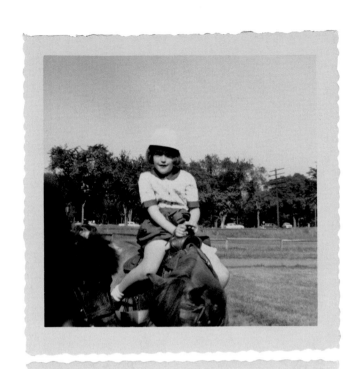

JANET LEE
RIDING A
REAL PONEY

JANET HAD
A LITTLE
SPELL AT
POINTER'S
CABIN WHILE
SHE SAT ON
THE DAVENPORT.
SO I SNAPPED
THEM AFTER
IT WAS OVER.

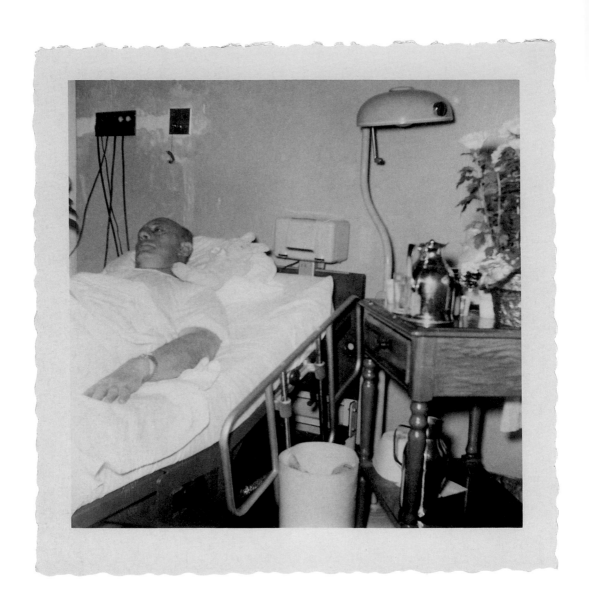

248

HAROLD –
ULSER FEELING
BETTER WITH
REST AND PROPER
FOOD.

JANET AND
GAYLE
PLAYING IN OUR
ATTIC.

ONE OF JANET'S
LITTLE FRIENDS

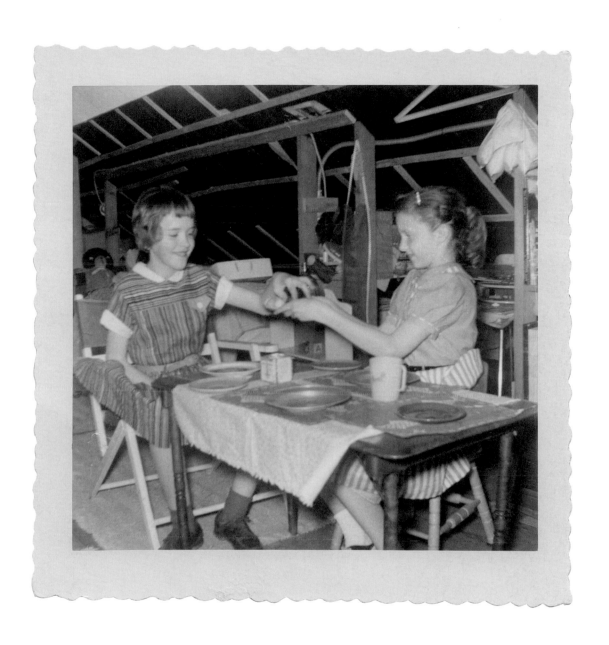

251

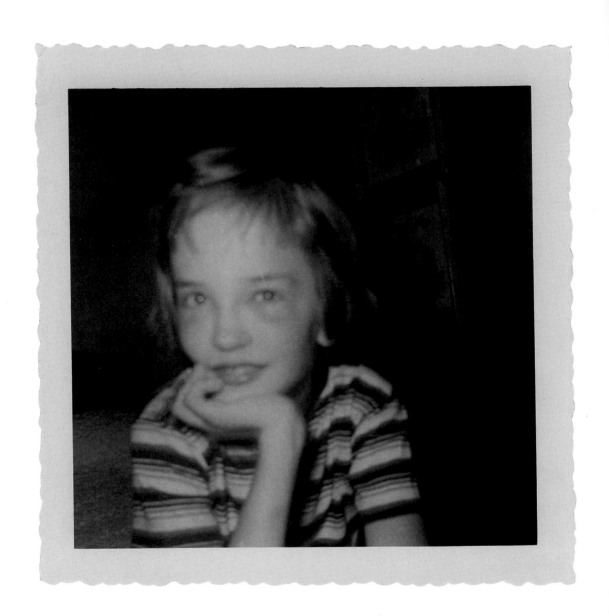

252

JANET LEG
AFTER LAST
FALL ON BEDROOM
FLOOR — LOOKED
SO PATHETIC
WITH SWOLLEN
BRIDGE BETWEEN
HER EYES
7 X-RAYS ON MAY 30th
AT ABBOTT HOSPITAL —
TOLD NO BROKEN BONGS
SHOULD BUY A HELMET FOR
HER.

253

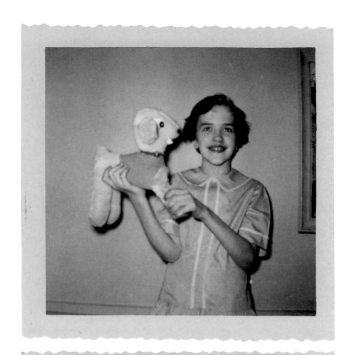

JANET
AND HER
NEW STUFFED
LAMB

THIS STUFFED ANIMAL
I GAVE TO ABBOTT
HOSP.

254

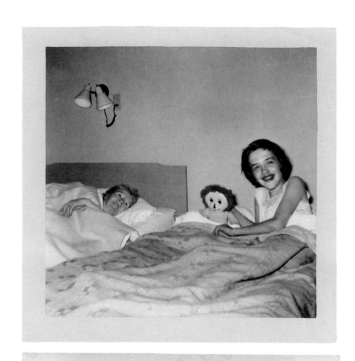

JANET
LEE
AT GRANDMA B's
HOUSE IN PHARR,
TEXAS.
JUNE 1959
THE LAST TIME
SHE WILL EVER
BE THERE FOR
SHE DIED
AUG. 18-1959
IN ABBOTT HOSP.

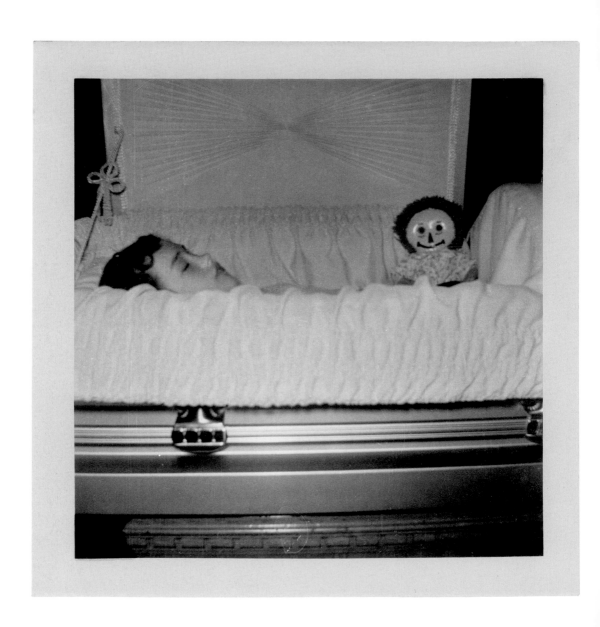

256

257

JANET WAS
10 YEARS OLD

JUST
 READY FOR
 BED,
 AUNT SUNNY
XXX TO YOU

GOOD NIGHT

SWEETHEART.

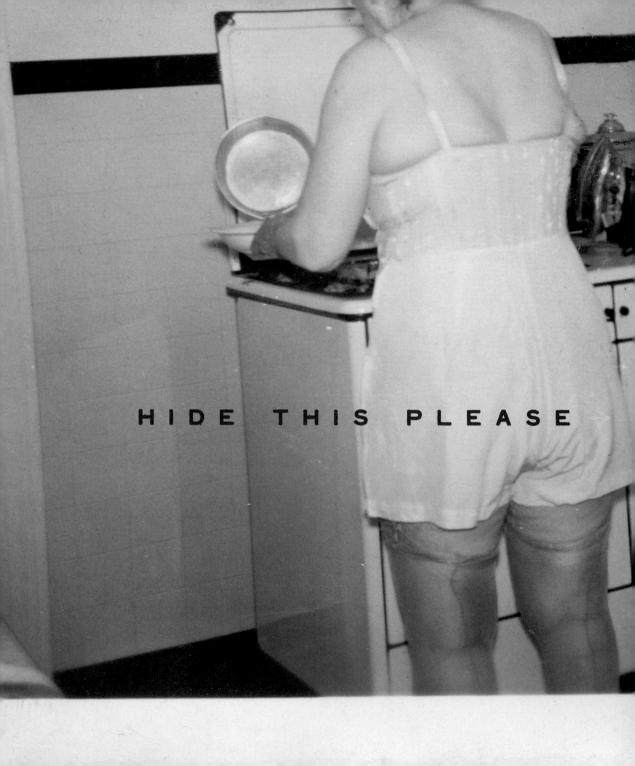

HIDE THIS PLEASE

Old fat me

P.S
Hide This Please

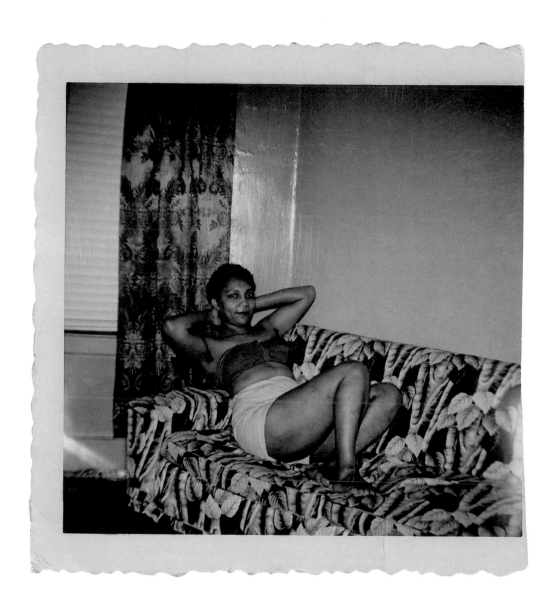

265

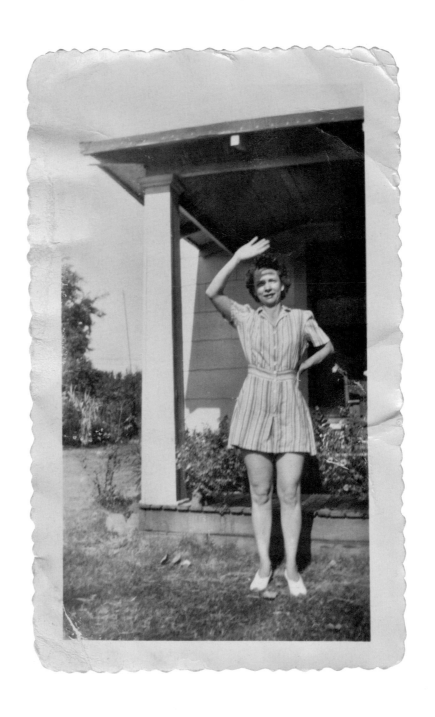

266

Certainly my legs
wont cause Betty
grable any envy

Tear this up.

This is
my
Picture.

Ha Ha

268

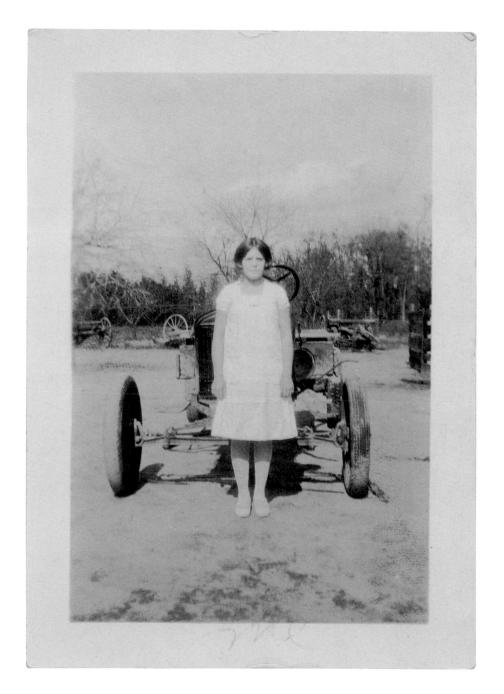

269

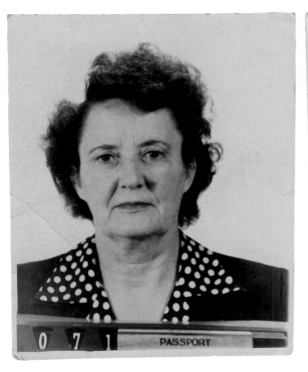

Isn't this a
beauty?

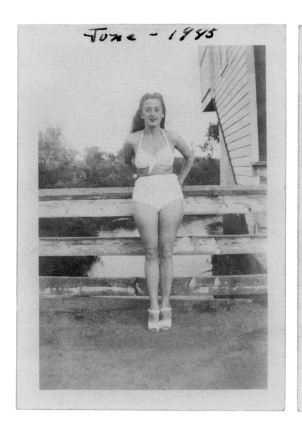

June - 1945

This is really awful.

568

They wouldent wait for me to clean up.

272

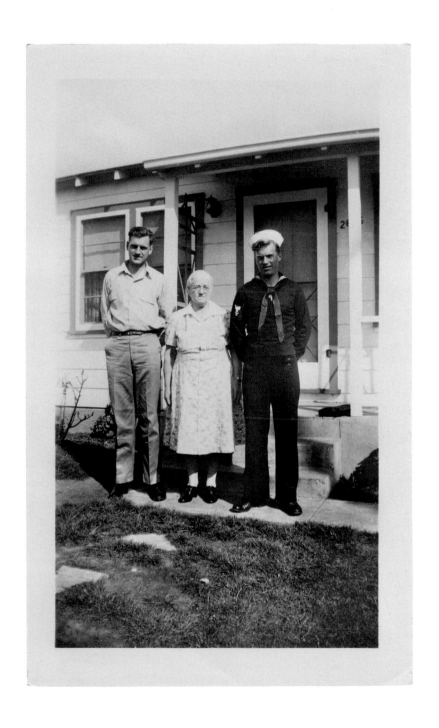

273

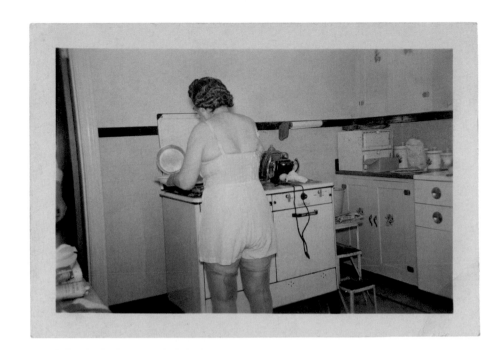

Phil took this
flash of mom while
she was getting
supper tho nite

Some P in up girl

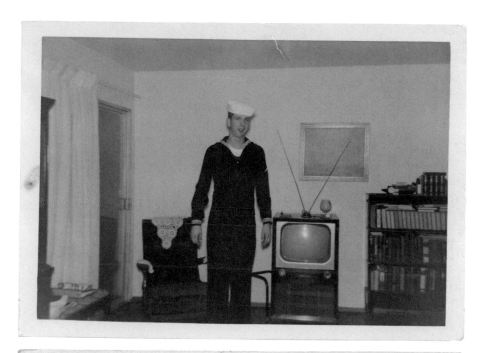

MOM TOOK This just
us I moved and said
fudge.

9448

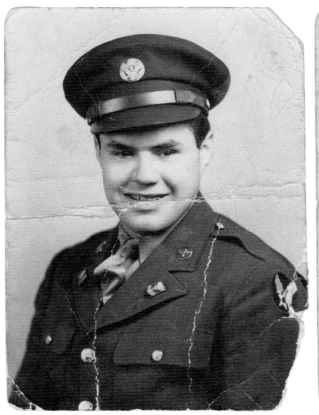

Heres another
Picture of
My Ugly puss.

276

This photo was awarded
the prize in the beauty
show. It is with great
pleasure we present
it for the first time
to the American
public.
 Kind regards to friends
& Knockers Bill
 and
 Bird

Goodness sakes pull down your dress! You're a big girl now

279

A big rear but the fad isn't bad. At least its me.

282

This is Anne in
her $50 gabardine
suit her Dad gave her.

She gets sweeter all the
time but no thinner!

We were wondering
which was the larger
the log or the leg

285

Tell Rick look at his fat
Sister in law

AUG • 61

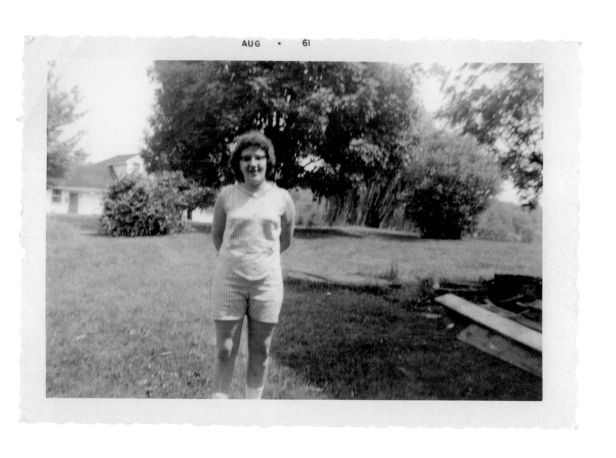

287

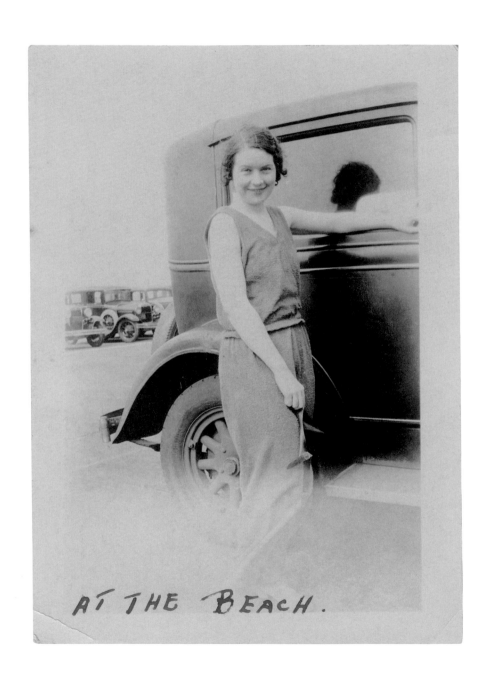

AT THE BEACH.

I'm not as fat as I look here, its the terry cloth pajamas over my bathing skirt plus wind —

I'M NOT AS FAT AS I LOOK HERE, IT'S
THE TERRY CLOTH PAJAMAS OVER MY
BATHING SKIRT PLUS WIND.

I am not this fat I have on

Wool underwear
Wool sweatshirt
Wool shirt & pants
Wool sweater
Leather jacket
Gaberdine flying suit
Wool sock
G I shoes
Rubber bear skin boots
Leather pants bear skin
Leather coat bear skin lined.
I also wear a oxygen mask that covers my entire face
Life saver vest
Parachute

229

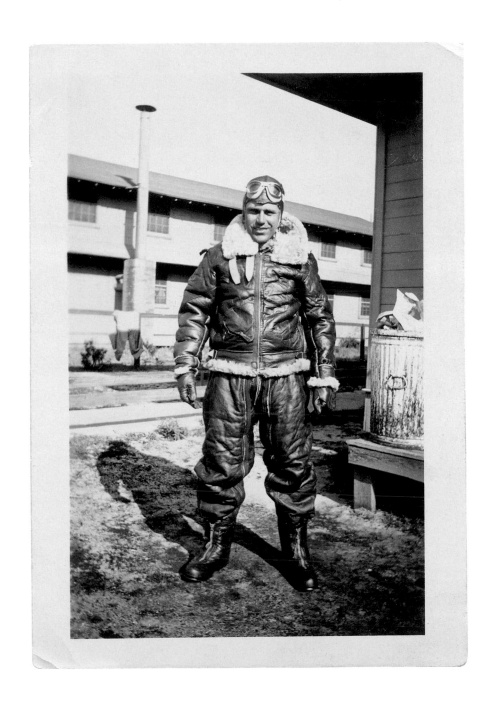

291

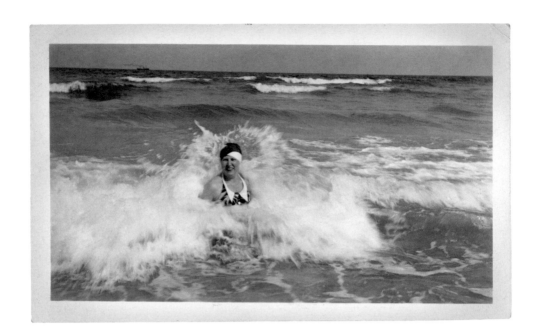

Ruth raising the water level
at Miami

200

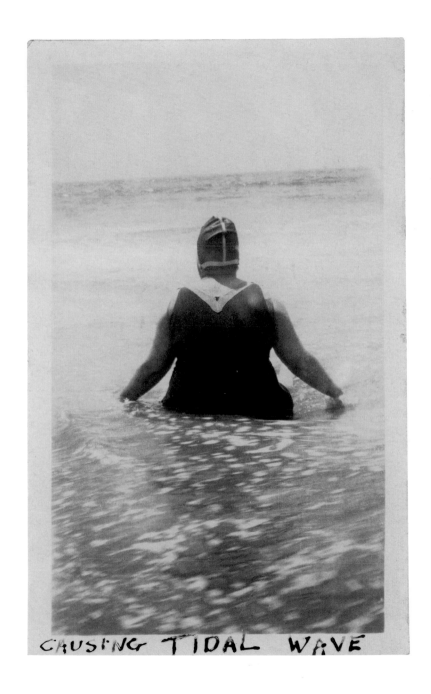

CAUSING TIDAL WAVE

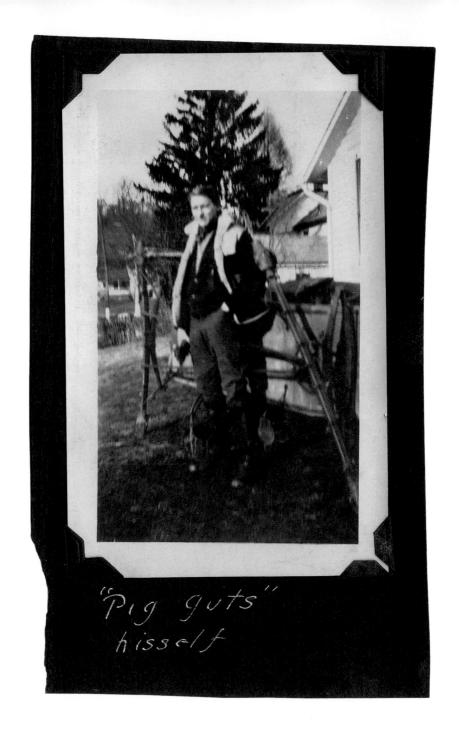

"Pig guts"
hisself

294

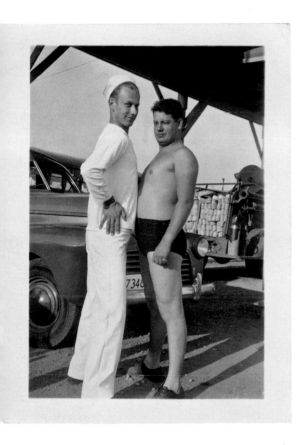

BuzzArd NecK +
HAMFAT

The Limburger Kid
King of the front
Lawn.

296

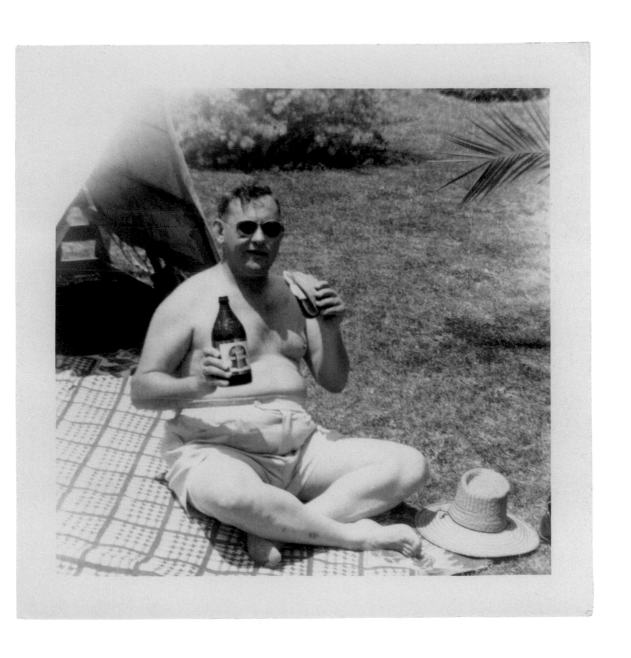

297

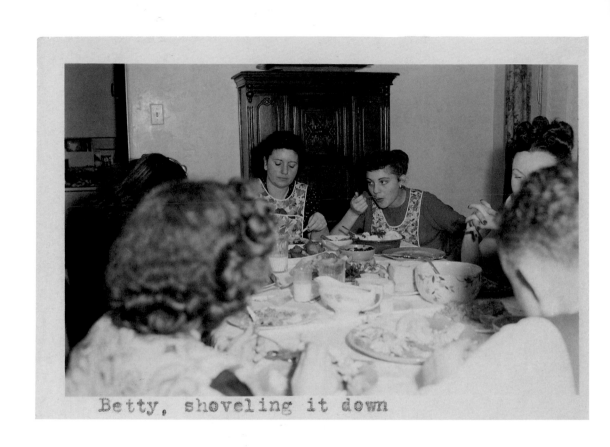

Betty, shoveling it down

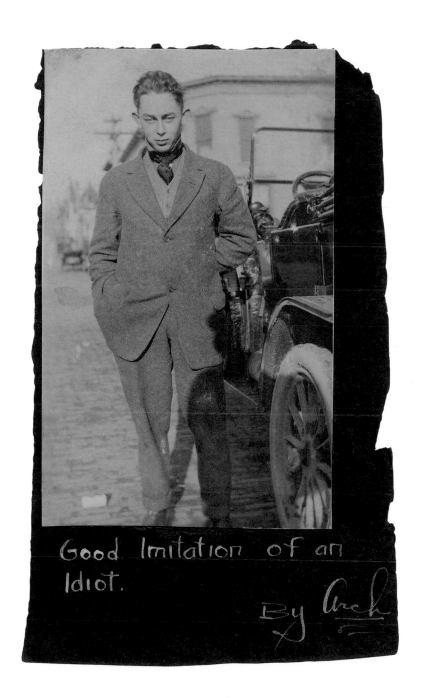

Good Imitation of an Idiot.

By Arch
X

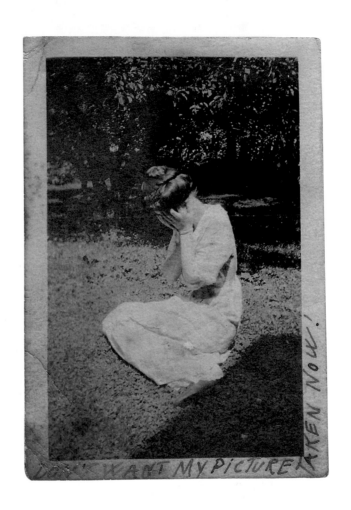

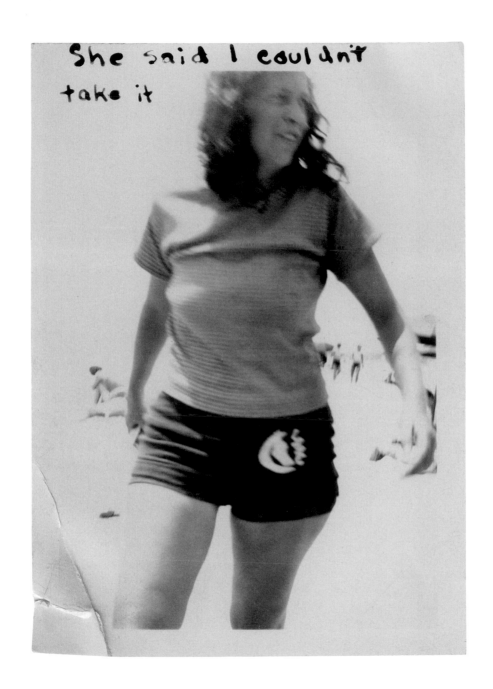

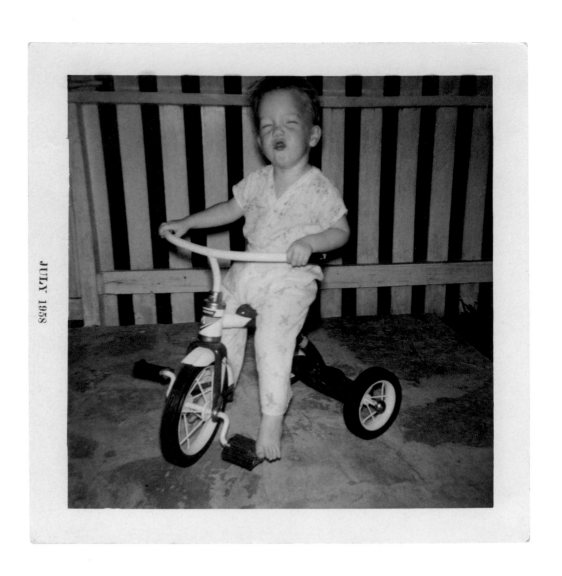

JULY 1958

I Asked Walter if
he wanted his picture
took t he said

NOOOO

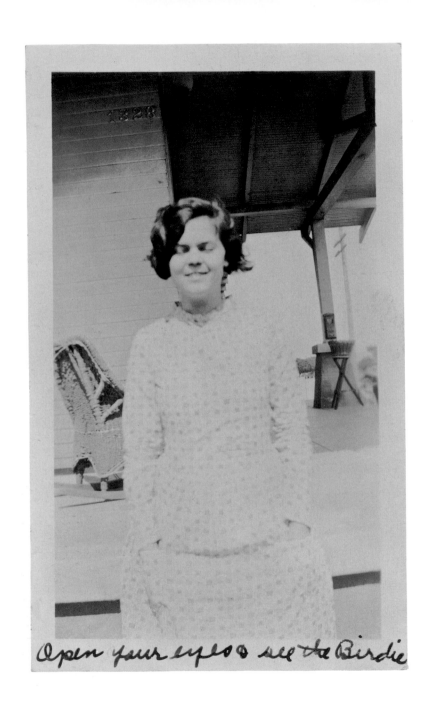

Open your eyes & see the Birdie

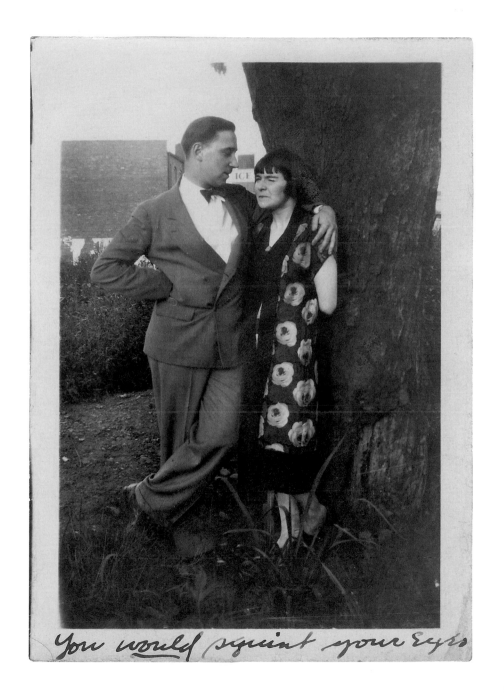

You would squint your eyes

The Camera man
Knows Better how
and where to Shoot
a fat man With
a B. B. rifle than
how to Shoot a
Picture

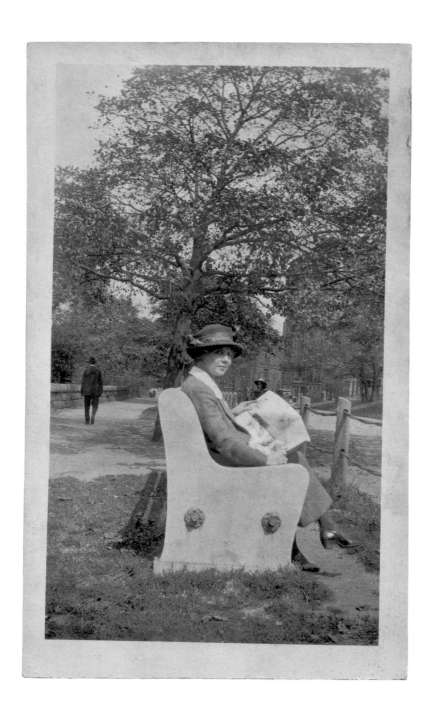

307

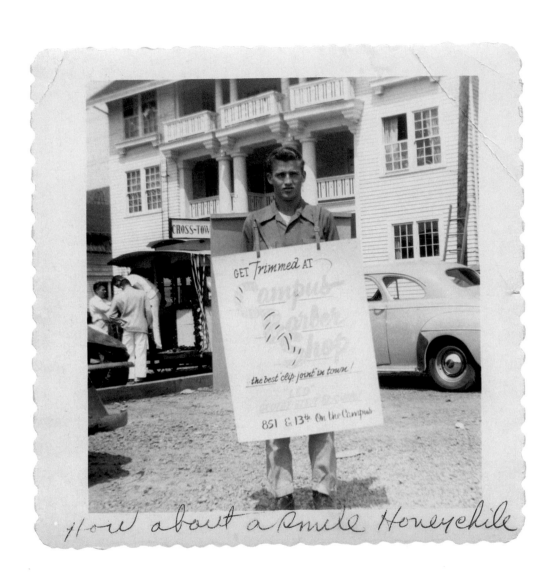

How about a Smile Honeychile

308

Oops! Sandy

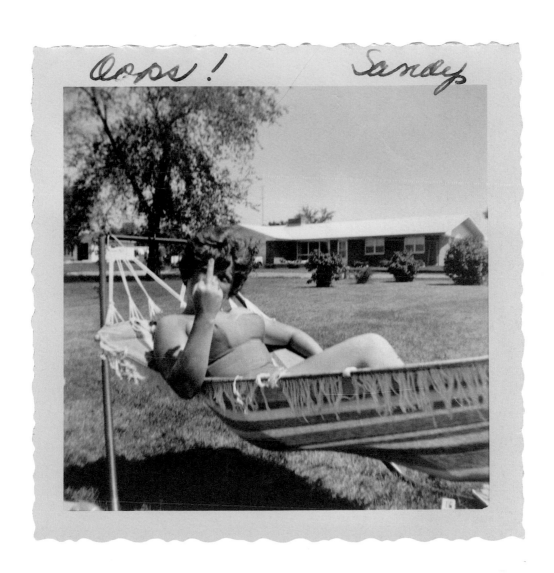

Oct. 7, 1945

I can't smile. they
call me "Sourpuss."

310

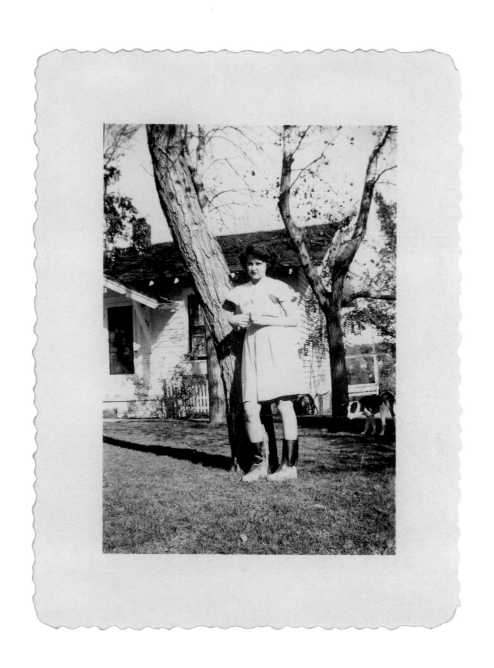

311

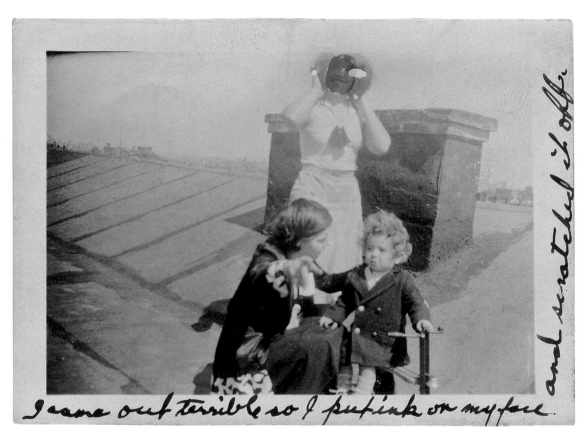

I CAME OUT TERRIBLE SO I PUT INK ON MY FACE
AND SCRATCHED IT OFF.

this one came
out terrible
don't show it
to any one.

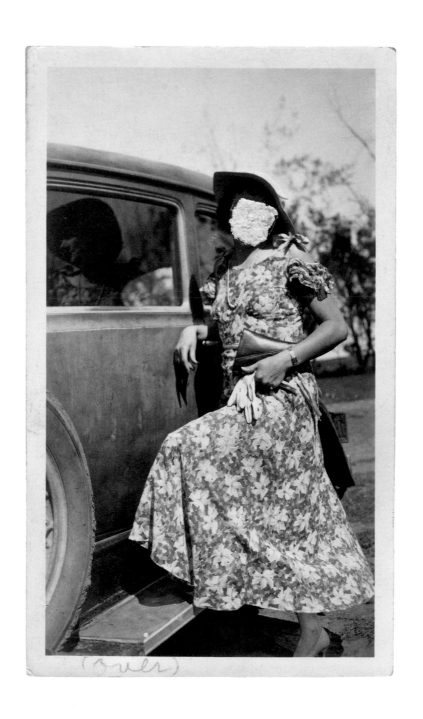

(over)

314

Don't you think
this is the best
picture I ever
had taken?
I think my
face is so
natural.

Well This is me.

316

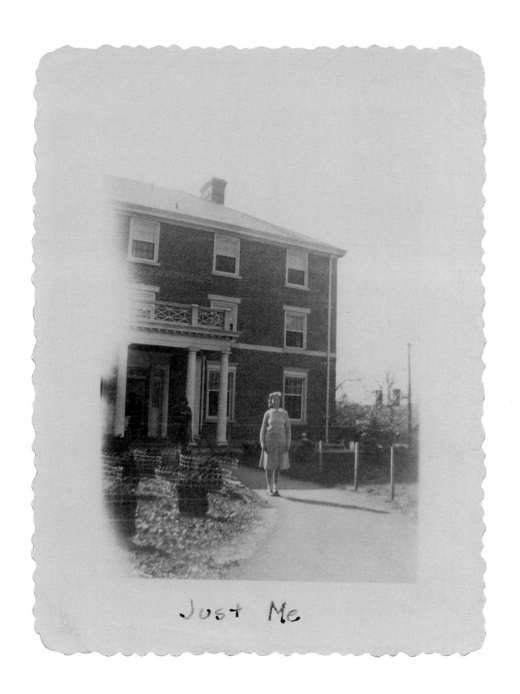

Just Me

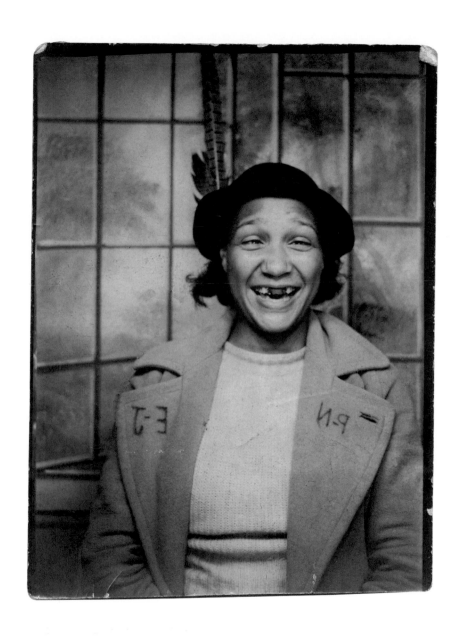

318

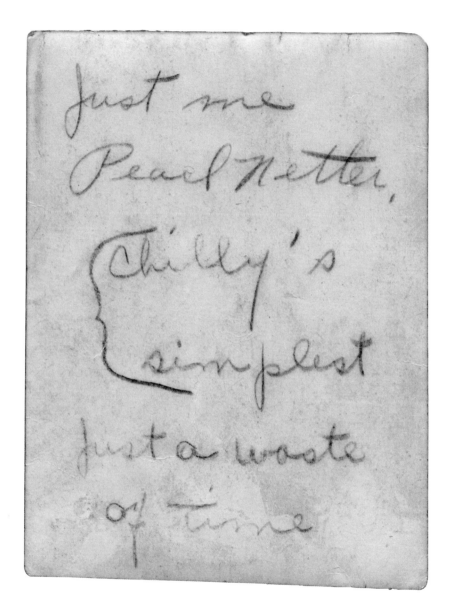

JUST ME PEARL NETTER.
CHILLY'S SIMPLEST
JUST A WASTE OF TIME

UNSOLVED MYSTERIE

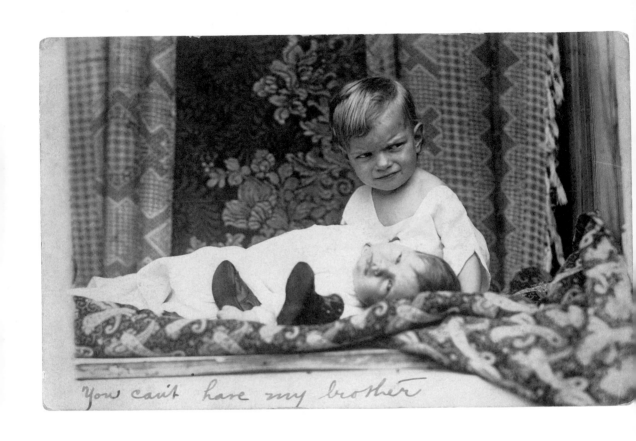

You can't have my brother

322

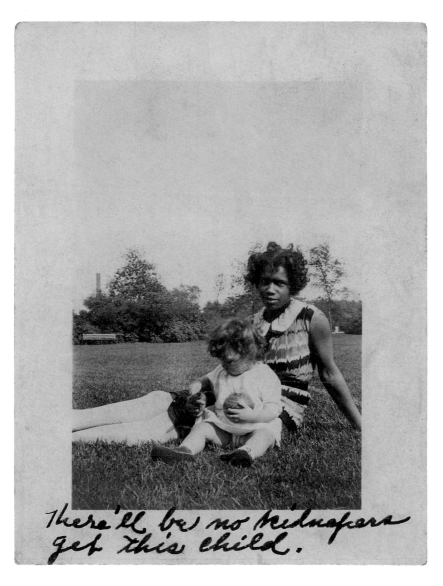

THERE'LL BE NO KIDNAPERS GET THIS CHILD.

This is what I got
in Fla.

19

324

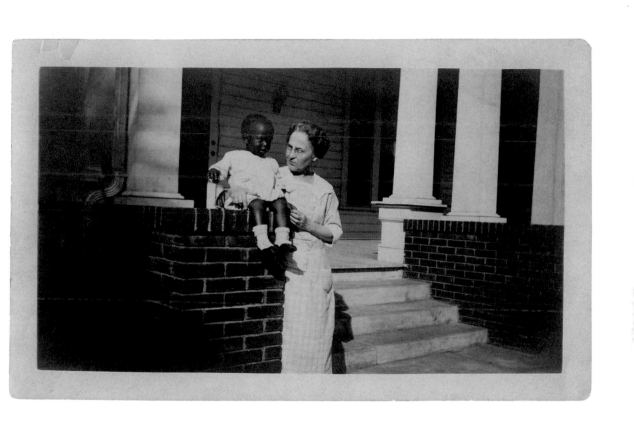

326

Jud Lyons
(~~sister of 1st made~~
(Brother of 1st made
Lyons Crankshaw
Born: May 18, 1850
Died:

Disappeared
about 1900

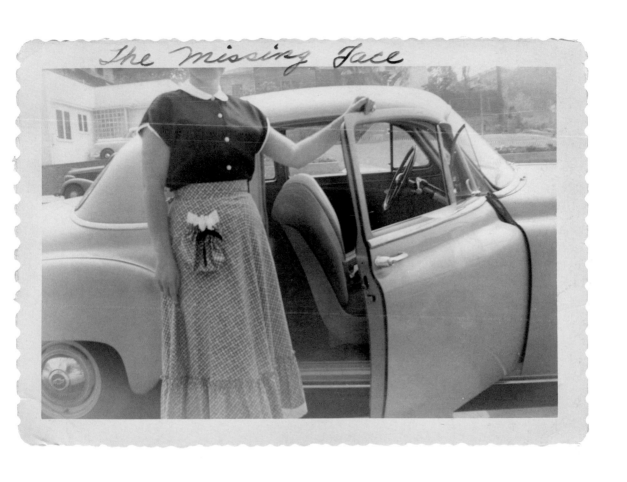

The missing face

329

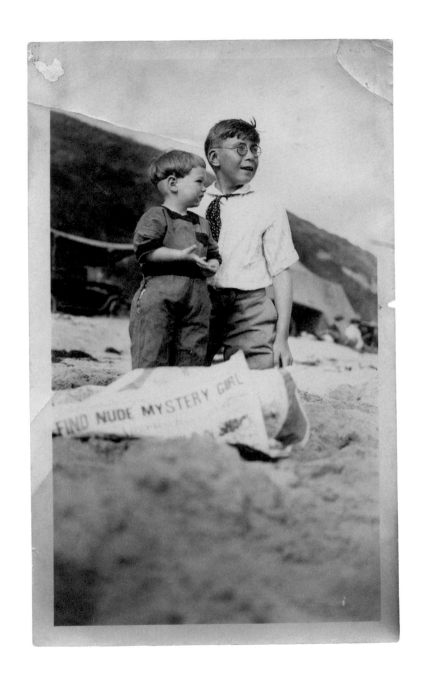

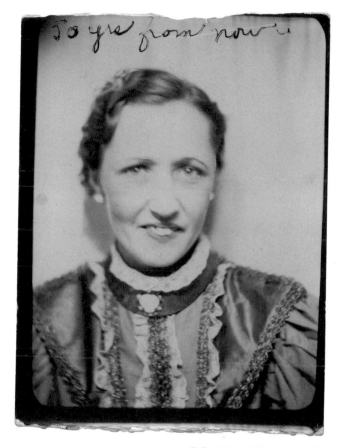

50 YRS FROM NOW

Vienna
Nov 24, 1990

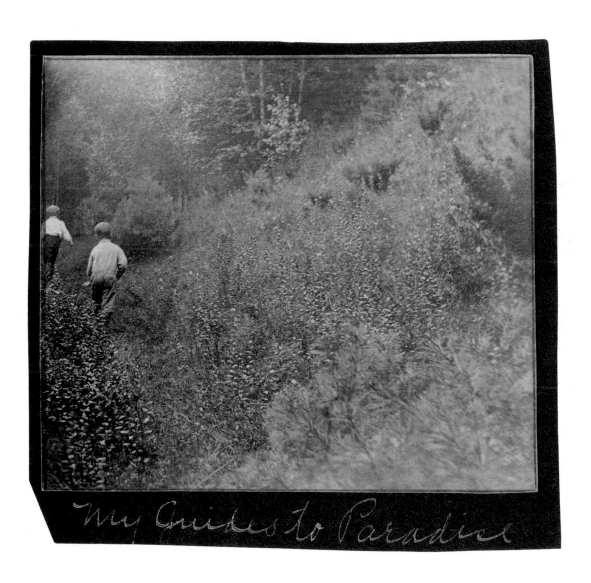

My Guides to Paradise

Sleeping Beauty's Castle

Disneyland

August 83

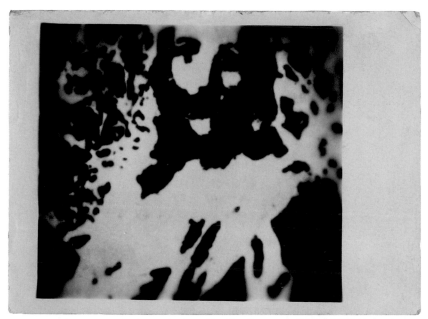

IMAGE OF JESUS ON COW

336

This is just a small
portion of my room

E332011WA

337

Let no one dare this
 card to turn
Lest you see the image
 of the evil one.

338

339

otherwise
known as
Draculas
sister

1949

TWO BIT
LIZZY

341

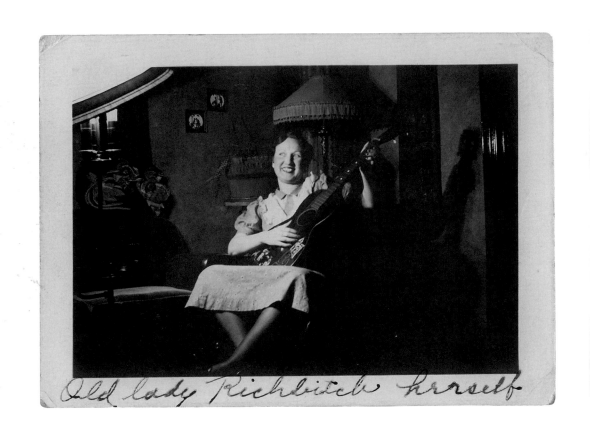

Old lady Richbitch herself

342

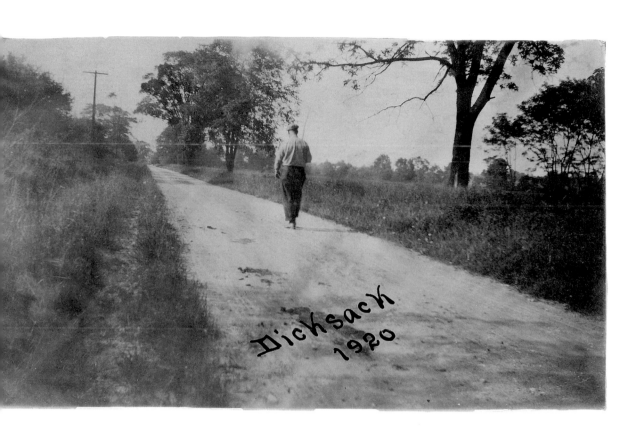

Dicksack
1920

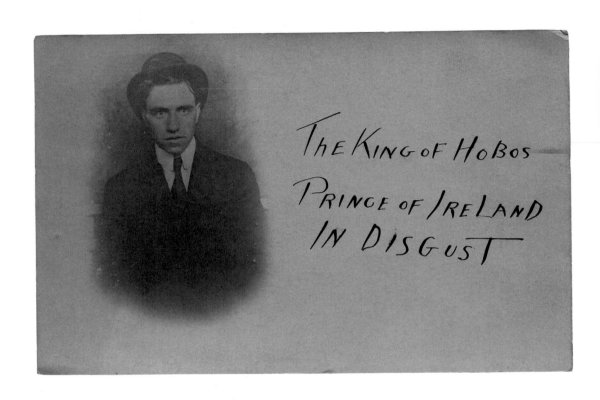

The King of Hobos
Prince of Ireland
In Disgust

344

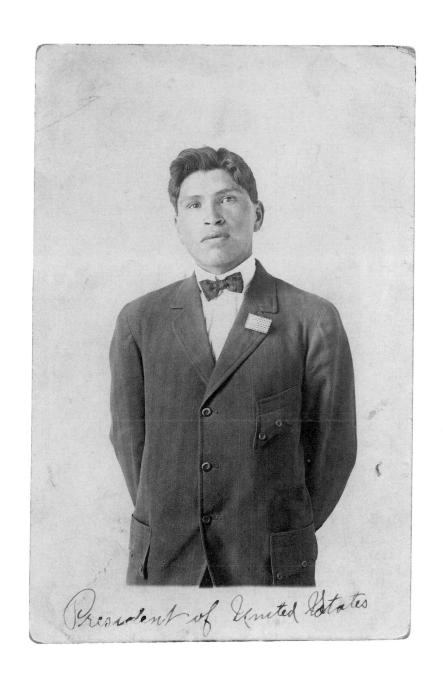

President of United States

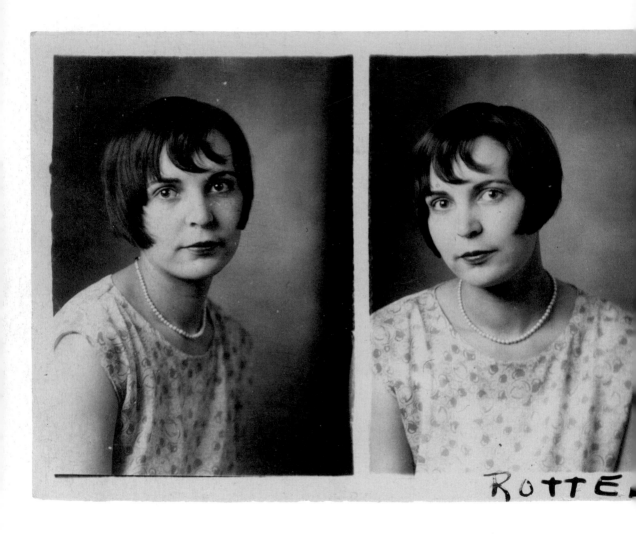

ROTTE.

346

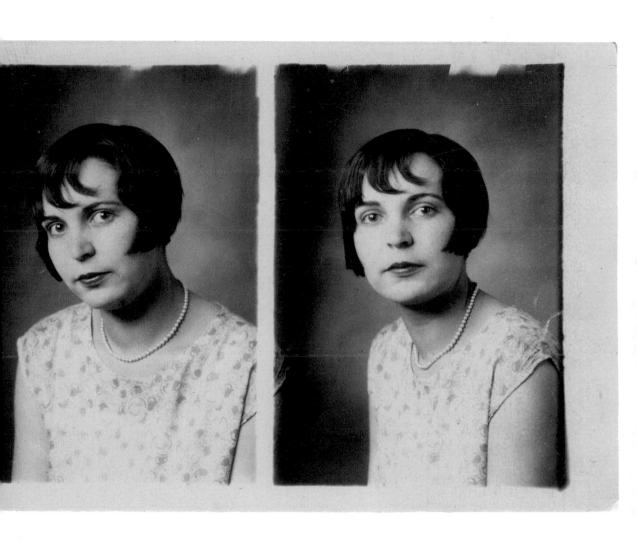

347

POST CARD

CORRESPONDENCE HERE FOR ADDRESS ONLY

Shot at
and missed

MADE BY INTERNATIONAL STUDIO
943 W. MADISON ST., CHICAGO

348

349

POST CARD

For INLAND Postage only this Space
may be used for Communications

THE ADDRESS ONLY TO BE
WRITTEN HERE

May this face, comfort
and soothe, through
the long watches of the
Night.

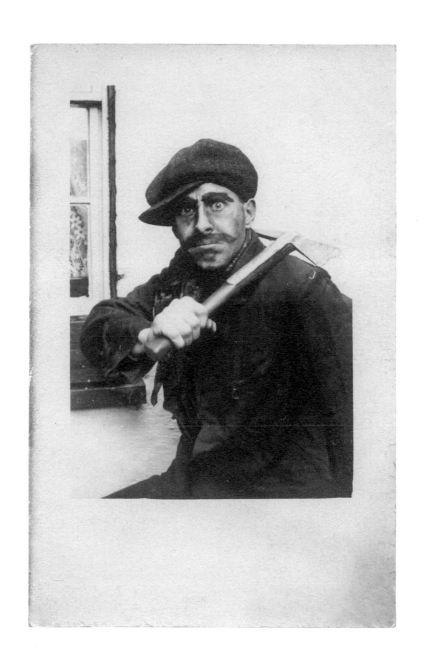

351

This man took care of the brushing of teeth before the heads could be roasted.. He is convicted of not using Colgates tooth paste. So he got drafted.

THIS MAN TOOK CARE OF THE BRUSHING OF TEETH BEFORE
THE HEADS COULD BE ROASTED. HE IS CONVICTED OF NOT USING
COLGATES TOOTH PASTE. SO HE GOT DRAFTED.

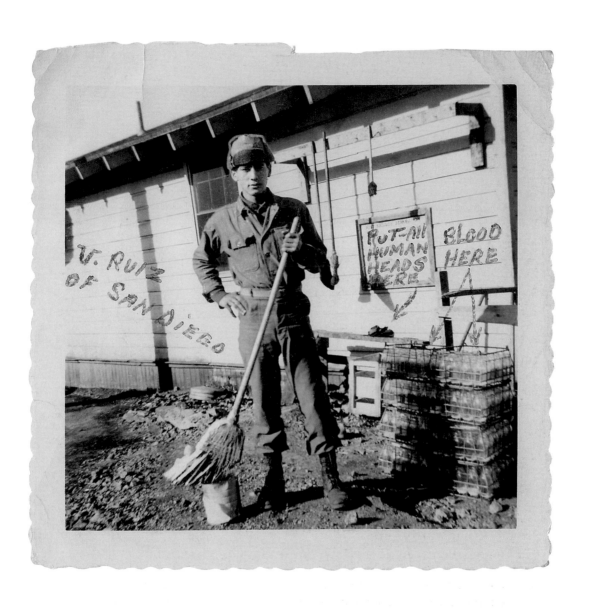

353

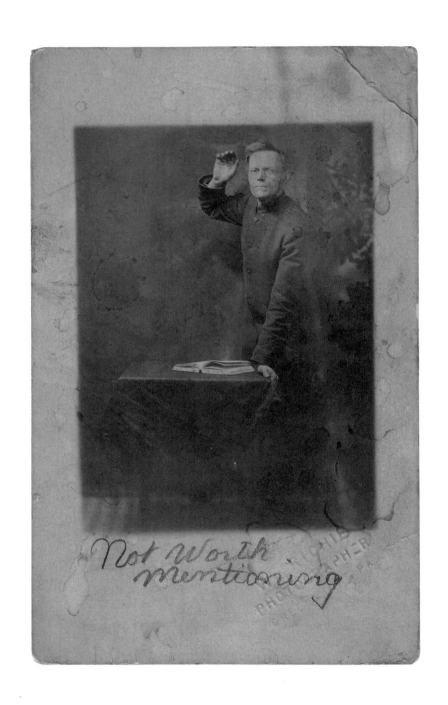

Not Worth Mentioning

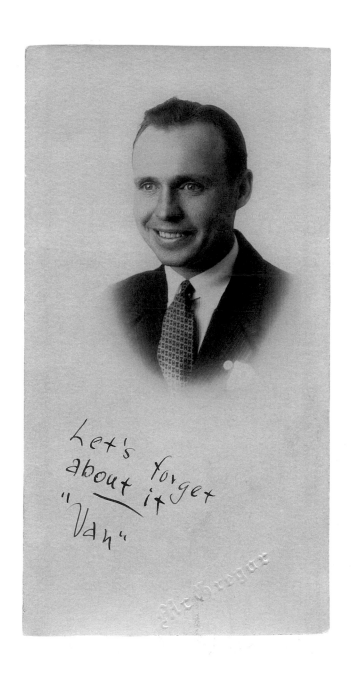

Let's forget about it
"Van"

355

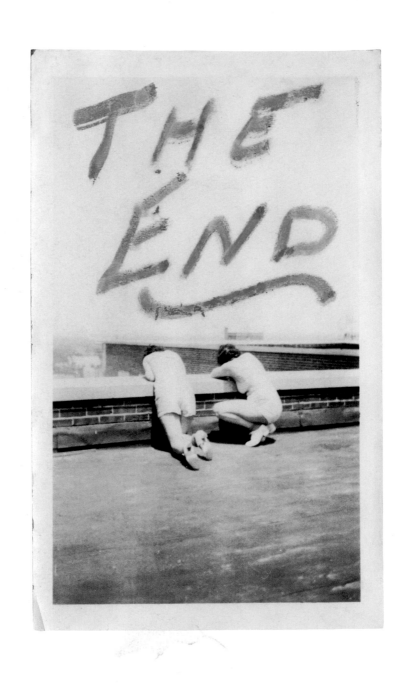

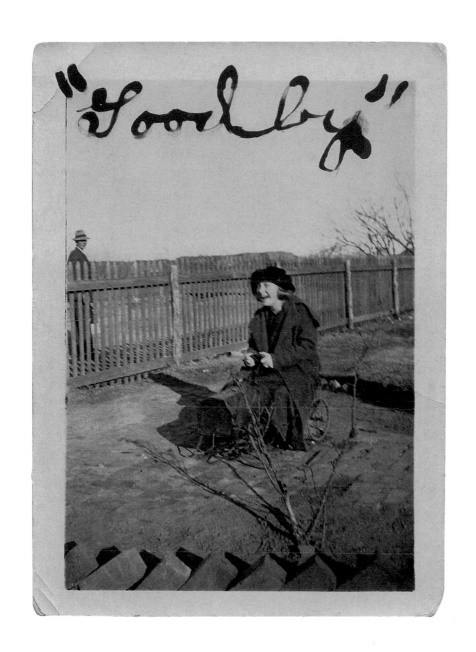

"Goodby"

TOOK THIS JUST T

64

ₙiSH Roll of FILM

359

AFTERWORD ❖ ❖ ❖

936 △

→ → → → → → → → → → → → →

People don't write on the backs of photos much anymore. That's because we don't write on anything as much as we used to—at least, not in a traditional, pen-to-paper sense. Nor do we even take photos—by which I mean real photos, printed on paper coated with photo emulsion. Cameras have proliferated as never before, but the images they produce are ephemeral strings of ones and zeroes, rarely printed, stored on chips and drives that are easily damaged or erased, susceptible to heat, magnets, wear, and obsolescence. A hard drive might last five years, a compact disc ten or fifteen. A well-printed snapshot will still be visible after a century—negatives even longer.

We are no longer leaving behind a tangible, enduring photographic record of ourselves. Future generations will be far less likely to find our creased snapshots in dresser drawers and attic trunks, as we did those of our ancestors. Which is to say: old photos may seem numberless now, but they are being lost and tossed at an alarming rate, and we're not making new ones. They're an ever-diminishing and increasingly precious repository of knowledge about our past and ourselves, a visual history of who we were and the way we lived. The passage of time makes old photographs more than just someone else's memories. When names and faces are forgotten, they pass into collective memory. In a sense, they belong to all of us.

It's my hope that someday soon the act of collecting and saving old snapshots will be more than just the unusual hobby of a few, and that we'll stop dismissing them as just "other people's pictures." There are a few places in the United States—like Los Angeles, with its robust flea market scene—where these photos have a better-than-average chance of escaping the dumpster. But even there, these precious pieces of our history, some of them unintentional masterworks of photography, are thrown away every day. If nothing else, I hope this book inspires a few people to take a second look at Great-aunt Susie's old pictures before they fall victim to an aggressive spring cleaning.

Before you throw anything out, be sure to glance at the back.

ACKNOWLEDGMENTS

I need to thank:

My mother, for giving me that Pentax camera for Christmas when I was thirteen, and for saving all our old family photos.

My wife, Abbi, for her endless assistance and encouragement.

My agent, Kate Shafer Testerman, who believed in this project from its earliest stages.

My editor, Calvert Morgan, for his sure-handed guidance.

My photo collector friends, for helping me find and lending me many great images, for allowing me into their homes and lives, and without whose enthusiasm this book would not exist. Many thanks to Steve Bannos, Robert E. Jackson, Peter J. Cohen, Erin Waters, John Van Noate, David Bass, Leonard Lightfoot, Roselyn Leibowitz, Angelica Paez, Stacy Waldman, Albert Tanquero, Michael Fairley, Ben Zeigler, Sarah Bryan, and Lynne Rostochil.

PHOTOGRAPHY CREDITS

2–3: "Me + My Gal", 57: "How I Will Look"; 127: "Train Hit Mr. King's Truck"; 148–49: "And My Dear Baby"; 158–59: "Leaving Home for War"; 160: "God Return Them Home Safely"; 294: "Pig Guts Hisself"; 318–19: "Just a Waste of Time"; 344: "The King of Hobos"; 348–49: "Shot at and Missed"; and 356: "The End" all courtesy of David Bass.

7: "Drunk but Happy"; 27: "Highway Robbery; 34: "Scrubbed"; 38–39: "Just Clowning Around"; 42: "Sweet Sixteen"; 43: "Just an Amateur"; 50: "To My Weakness"; 51: "Hot Stuff"; 53: "Saddle Your Blues"; 104–5: "Stealing Everything"; 124–25: "Locusts"; 173: "Flying Lead"; 208: "End of World War II"; 299: "Imitation of an Idiot"; 305: "You Would Squint Your Eyes"; and "Deer Head" all courtesy of Peter J. Cohen.

17: "A Bad Scene"; 28: "Suicide + Murder"; and 31: "The Ostrich Himself" all courtesy of Robert E. Jackson.

44: "An Explanation"; 143: Mabel; 146–47: "While Hazel Was Sick"; 222–23: "Boxcars"; and 226–27: "SS Men" all courtesy of John Van Noate.

46: "Hatless Blondy"; 62: "Wish I Had a Girl"; 234: "Good Luck Charm";

277: "First Prize in the Beauty Show"; and 322: "You Can't Have My Brother" all courtesy of Erin Waters.

55: "Lost Weekend"; 84: "Best Is Yet to Come"; 179: "Miss Hicks"; 298: "Betty Shoveling It Down"; 317: "Just Me"; 343: "Dicksack 1920"; 255: "Let's Forget About It"; and 357: "Goodbye" all courtesy of Roselyn Leibowitz.

85: "We'd Been Married 1½ Hrs"; 138–39: "A Perfect Picture"; and 290–91: "Not as Fat as I Look" all courtesy of Angelica Paez.

108: "Louisville Mugshot" and 109: "New York Mugshot" both courtesy of Albert Tanquero.

202–3: "From My Stateroom Porthole" and 224–25: "Dog Kennels" both courtesy of Stacy Waldman.

228–29: "A Mental Wreck" courtesy of Lynne Rostochil.

354: "Not Worth Mentioning" courtesy of Sarah Bryan.

358–59: "Just to Finish Roll of Film" courtesy of Robert E. Jackson.

Photograph by Lara Porzak

ABOUT THE AUTHOR

Ransom Riggs is the author of the #1 *New York Times* bestseller *Miss Peregrine's Home for Peculiar Children*, a novel illustrated with found photographs. He's a filmmaker and a photographer, too, though he's convinced he'll never take a picture to rival some of those he's found at flea markets. He lives in Los Angeles.